Praise for David Creedon

'Creedon's meticulously made photographs document the interiors of abandoned homes in rural Ireland.' **Aidan Dunne,** *The Irish Times*

'Creedon has immortalised distinctly Irish abandoned cottages as they have started to crumble with decay and neglect and an impossibly tangible sense of loss.' **Sophie Gorman,** *Irish Independent*

'David Creedon's images imbue in me the kind of romanticism I first felt, when aged fourteen, as I looked at a small reproduction of 'From the Back Window, 291' by Alfred Stieglitz, 1915, NY. They transpose you to an almost mythical place, that were you able to visit, could only fail to live up to the beauty captured so precisely and soulfully by such artists as Creedon and Stieglitz.' **Nigel Watts, Photographic lecturer, Henley College, UK**

'It's almost like a *Mary Celeste* exhibition for a whole nation, of a place that has been left deserted; it's extraordinary there is a ghostly present in all the pictures.' **Barry Devlin, RTÉ Six One News**

'David Creedon's *Ghosts of the Faithful Departed* evokes an Ireland that was [and] captures apparently forgotten traces of lives lived, in spaces that have not yet been reclaimed and renovated. The photographs have been made with a clear eye for quite formal, planar compositions and a keen sensitivity to colour and texture. In evoking the traumas and transformations of our history, the high hopes of those who left our shores and the slow, painful transformations experienced by those who stayed [...] the images also invite association with our contemporary experience of migration – immigration – and what lies in its wake.' **Siún Hanrahan,** *Irish Arts Review*

'Powerful, a great piece of work altogether.' **Eamon Carr,** *Evening Herald*

'David Creedon's images are fantastic – amazing colour.' **Melissa Dewitt, Editor,** *HotShoe International*, **UK**

'Mind-blowing – stunning in their impact and content.' **Lauren Heinz, Editor,** *8 Magazine*, **UK**

'Unlike the new and empty holiday-homes, these abandoned homes have memories, they have stories to tell.' **Daniel Hickey,** *Western People*

'These haunting photographs transcend the documentary form and enter the realm of art. They are poems in photographs.' **Kevin Hegarty,** *The Mayo News*

'It is David Creedon's ability to empathise with and reflect what he sees, which makes this such a powerful exhibition.' **Vincent Kelly,** *Evening Echo*

'Creedon captures the lingering mood of departure in Ireland's rural areas within his hauntingly beautiful photo essay, *Ghosts of the Faithful Departed*.' **L. Cerre, San Francisco**

GHOSTS OF THE FAITHFUL DEPARTED

David Creedon

The Collins Press

FOREWORD

David Creedon's photographs encapsulate the overlooked and unacknowledged experiences of those who stayed in rural parts of Ireland during the twentieth century when family members and friends left for cities in Ireland, England, the US and elsewhere. They also capture the prevalence of the iconography of Catholicism in the everyday home life of rural Ireland.

Low rates of marriage and high levels of emigration due to poverty and inheritance patterns meant that Ireland's population trends in the mid-twentieth century had a pathological quality. Indeed, it is the only country in modern times to have sustained more than 100 years of population decline. However, since the 1960s, the dominant national narrative has been one of breaking from a past of stagnation, emigration and Catholic moral restriction and embracing economic growth, globalisation and consumer culture. Until very recently, it seemed possible that most of those young people who wanted to stay in Ireland would be able to achieve economic security and realise their dreams here. Therefore, this photographic project provides a timely reminder of the ambitions of Irish citizens in the twentieth century who either couldn't make a life for themselves in Ireland or whose lives in Ireland were lived in the absence of sons and daughters, sisters and brothers, neighbours and friends.

These photographs rely on our expectation that interiors and homes are filled with people, but in these homes the people are gone. Their absence forces us, as viewers, to construct stories about the woman who wore the pink dress in the wardrobe, the returned emigrant and her trunk of 'goodies' from the US, the child in the pram and where he or she might be now, the desires, hopes, dreams and prayers that were directed at these religious pictures and statues. We begin to think beyond the statistics and the public focus on male emigrants when the traces of emigration are re-located in the spaces and the artefacts of the home.

I'm not surprised that the *Irish Independent* newspaper billed David Creedon as 'Cork's Vermeer' because the colours, tones and light in the photographs create moods of expectation, curiosity and reflection that bring these interiors alive. The play of shadow and light creates the effect of paintings rather than photographs. Any one of these photographs tells many stories, contradictory and conflicting stories, stories of life and times that connect Ireland and many places beyond Ireland's shores in the twentieth century. Each of them renders those absent palpably present as ghostly figures of the imagination.

In a busy speeded-up world, these photographs suggest a sense of time standing still and of a photographer/artist who took the time to capture the stillness, the moment that extends backwards and forwards in time, the echoes of voices of previous inhabitants now gone to another world or another place in this world, and the expectation of what is to happen next. What fate will befall these fragmentary reminders of the not so distant past and the material existence of these houses, rooms and artefacts?

Just as those who lived in these houses may have been left behind by those who migrated, these houses have also been left behind, relegated to an irrelevant past by a speedy, disposable consumer culture. We are too busy moving forward, simply moving in whatever direction, to stop and look at these artefacts of our past and present and what they have to tell us about who we are, how we are

dealing with our history and our present, what tribute we want to pay to those who inhabited these places, to those who are gone, and what we want to pass on about these experiences to coming generations. These photographs bring such questions to the surface; they represent stillness, an artist who took time and they invite us also to take time.

All those who have lost parents/ friends/ relatives are aware of the knowledge and memories that die with people, but knowledge and memory disappear in different ways with the demolition or decay of homes and places. Memory is an important aspect of life, learning and love. Memory always involves forgetting, but it also requires memory work and decisions about what to preserve, how to represent it, pass it on, why and what it means. This collection of photographs contributes to the work of memory in a powerful visual way. Indeed, there are parts of the past that only memory knows.

Many note that we work at creating sites of memory when the real everyday environments of memory have disappeared. The everyday life of the people who inhabited these houses is no longer. The everyday collective memory that existed as part of that day-to-day life is replaced by a busy, mobile and media-saturated twenty-first century Ireland. These photographs are sites of memory that come into being as a conscious effort to limit the forgetfulness of this busy future-oriented life; they are moments in time that are torn away from the movement of history, encapsulated in an image and then returned to us to relocate in history and the present.

In 1999 and 2000, I was involved in a research project at the Irish Centre for Migration Studies at University College Cork that collected and archived life stories of those who stayed in Ireland in the 1950s when so many were leaving. The short quotes from three participants in this project below resonate with the stories of those who inhabited the houses in these photographs.

Stories from the *Breaking the Silence: Staying at home in an emigrant society* Archive

Sean* was seventy-five when interviewed. He grew up on a small farm in County Donegal, the fifth of nine children. He worked in construction in London and while he was there he met and married his wife who was also from Donegal (she worked in a factory in London). Although he worked in London for four years, Sean sees himself as the one who stayed. He has seven children.

> They all emigrated only me. But I was away myself you see and I came home
> ... at Christmas (1958) and the young brother that was here pulled away and
> left us stuck with my father ... There used to be tea boxes on the mantelpiece
> in them times ... and he (the brother who left) wrote a note and he put it
> sitting up like that and he put the tea box sitting on it for me father ... my
> father was on his own ... So I had to stay then and we're here ever since and
> we have seven children of our own ...

Mary, a widow and retired small farmer in County Cavan, was seventy years old at the time of interview. She was the second of six children and had six children herself. She made two attempts to emigrate, but her aunt (who adopted her when she was very young) did not want her to go.

* Names have been changed

At seventeen, when I went to go to America, my aunt said to me 'What's going to happen to me if you go?' And my uncle was at the drink, so I stayed … I had papers another time to go to England, to learn to be a nurse and my aunt got the papers and she was mad. I would have loved to be a nurse … There were ads for student nurses, your way paid and all … I remember the letter I wrote to Middlesex hospital … I thought if I went then and she didn't want me to go and things got sour, what would I come back to? They said … if I stayed on, whatever they had, they'd give it to me. And I said, it wasn't that, and she said 'What is going to happen to me if you're gone?' And I said I'd stay and she put her arms around me, she was delighted and I did stay. If I said a thing I would never go back on it …

Joe, a retired factory worker and small farmer living in County Roscommon, was sixty-five years old when interviewed. He is the youngest of four and is married with four children.

I had a kind of planned to go with this fella that worked with me in Hanley's factory at the time (1952) … A lot of the fellas that we started working with in the mineral factory had left … I suppose we felt that we were a kind of being left behind and that we were making no progress or anything … but I was in the FCA at the time and I went on a course in late November and I got rheumatic fever on the course and I spent up 'til the month of March in the army hospital in Athlone. During that time then he went, when I wasn't at home … So that ended that emigration. Now I doubt I'd have emigrated at the back of it, though I had more or less planned it. I never told my mother that I'd go or anything …

Staying at home in these stories is variously represented as a matter of obligation, entrapment and missed opportunities, but also as a matter of security and belonging, or simply 'the way things turned out'. For those on small farms and with little education, it was a matter of *having to* go because there were few opportunities to make a living in Ireland; and/or of *getting to* go because all chances of advancement were seen as lying outside of Ireland. As such, strategies had to be adopted to avoid being identified as the one who would stay, or to make sure to be the one who stayed. When escape was desired, the task was to avoid being trapped by family obligation.

Individual preferences with regard to staying or migrating were rarely openly articulated. To do so would be to break the communal silence, to challenge the collective denial and to name the pain caused by difficult familial dynamics of staying and going. Suggestion, silence and stubbornness seemed to be the most frequent modes of negotiating inheritance and family responsibilities including who got to stay or go. Perhaps the level of devotion to Catholic icons evident in this photographic project contributed to these structured silences and the privatisation of relevant political issues.

So, as well as providing comfort and homeliness, the rooms in these photographs un-housed some

* Names have been changed

and entrapped others. This collection of photographs bears witness to these intimate experiences of social and political forces. As such, David Creedon has made a powerful visual intervention in how we think about twentieth-century Ireland in all its colourful and not so colourful contradictions.

Memories that are different from or challenge dominant narratives can be seen as 'counter memories' and, in my view, these photographs speak back to dominant notions of Celtic Tiger and global Ireland. They confront us with old and new social imaginaries and otherwise inaccessible clues about the experience of the twentieth century and early twenty-first century. They also resonate uncannily with both the return of emigration and the empty homes in ghost estates around the country that may never be inhabited.

Dr Breda Grey,
September 2011

INTRODUCTION

I was never really sure whether I found the Ghosts of the Faithful Departed or if, in fact, they found me but a few years ago I was sitting in the back seat of my friend's car as we drove through the back roads of County Sligo. Out of the corner of my eye, I caught a glimpse of an old house and for no reason I asked my friend to stop the car. As I walked back the road I could see the house was deserted: the front door was open and it looked dilapidated. On entering the house, I could see that it was quite bare, the back door was also open and the house was obviously being used by sheep as a shelter, as was evident by droppings on the floor. I looked around although there was not much to see and, out of curiosity, I ventured upstairs and, when I walked into one of the bedrooms, the hair on my neck stood up at the sight in front of me: the room was painted a bright blue and, in the corner, there was an open wardrobe that contained a pink dress.

Months later, I was driving on an isolated road in County Kerry. In the distance I could see a house, which had the same look as the one in Sligo. As I drove closer, I saw there were no windows or door. When I walked in to the house, I could see it was also being used by animals as a shelter and, like the house in Sligo, it was practically bare of furniture. In one of the rooms, I found an old piano and on a chair next to it was a picture of the Sacred Heart. A couple of days later when I showed the photographs of both houses to a friend in West Cork, he declared that there was a house up the road 'just like those' and so began a journey that would take me more than two years to complete.

Photographing these houses I felt there was a story behind each one. I remember at one time listening to a radio interview with a politician who was advocating that the government give more financial aid to those Irish citizens living in Britain who were in need. These young men and women of de Valera's Ireland had no option but to emigrate. Leaving home at sixteen or seventeen they travelled on cattle boats and lived in doss-houses. They worked as navvies on the roads and the building sites, sending money home when they could so that their families could survive and, by doing so, took a burden off the state. Some became the vanishing Irish and today they are old, living alone, forgotten and in poverty.

> We forced and starved our young people out of this Republic with nothing except cardboard suitcases. Now we are leaving them old, homeless and alone to be buried as paupers in cardboard coffins.
>
> Emmet Stagg TD, 2004

It was not always possible to find stories from all the houses I visited but, from time to time, I was able to piece together people's lives from letters that were scattered around, and from examining the Census records and the Ellis Island immigrants' database.

I also came across research by Dr Breda Gray of University College Cork in a project she had conducted titled 'Breaking the Silence – staying at home in an emigrant society'. Dr Gray had compiled an oral archive of interviews with people who had stayed in Ireland in the 1950s and shared their experiences with her. As I listened to the interviews, it was clear to me that, individually, the people had stories that were unique to them but overall, they had a common thread that bound them all together.

Oh Ireland

Heather Brett

For Margaret & Katie McAleese

The second leaving,
a Spring day in March
and a railway station in the north.
and the very last time you see your sister.
She gets an hour off from the mill
to say goodbye forever.
Then Belfast, the docks, the pier awash with tears.
A boat to Southampton
for the liner out.
You're on your own now,
the first leaving back
when you fell for the protestant,
threw your hat in with the other crowd,
broke free from every sort of rope
that bound convention.
March sea, the cheaper fare.
A full week moored to your cabin
while the ocean swells,
falls back,
the waves move and thicken with ice.
Ireland behind you,
the Atlantic below
and a new found coastline beckons.
Those were the years of telegraphs and distance
thin airmails and funerals,
snow drifts, and lamps for the darkness.
All the leaving and the waiting,
to go or get there or even return,
two sides of the same tossed coin
a silver bright half crown,
or perhaps, that unfamiliar dollar.

The greatest resource that any country can have is its people, and yet the biggest exports Ireland ever produced were its sons and daughters. Over the years, thousands of people were forced to leave Ireland and this exodus led one author to question 'Are we becoming the Vanishing Irish and would we survive as a race if something wasn't done to stem the outflow?'

Those who stayed suffered continued hardship, isolation and social exclusion. Rural communities were decimated by the impact of emigration. Many of those who stayed during this decade did so in silence as they watched family members and friends leave. Now in a new millennium these people have passed on and their homes stand as a monument to a bygone age.

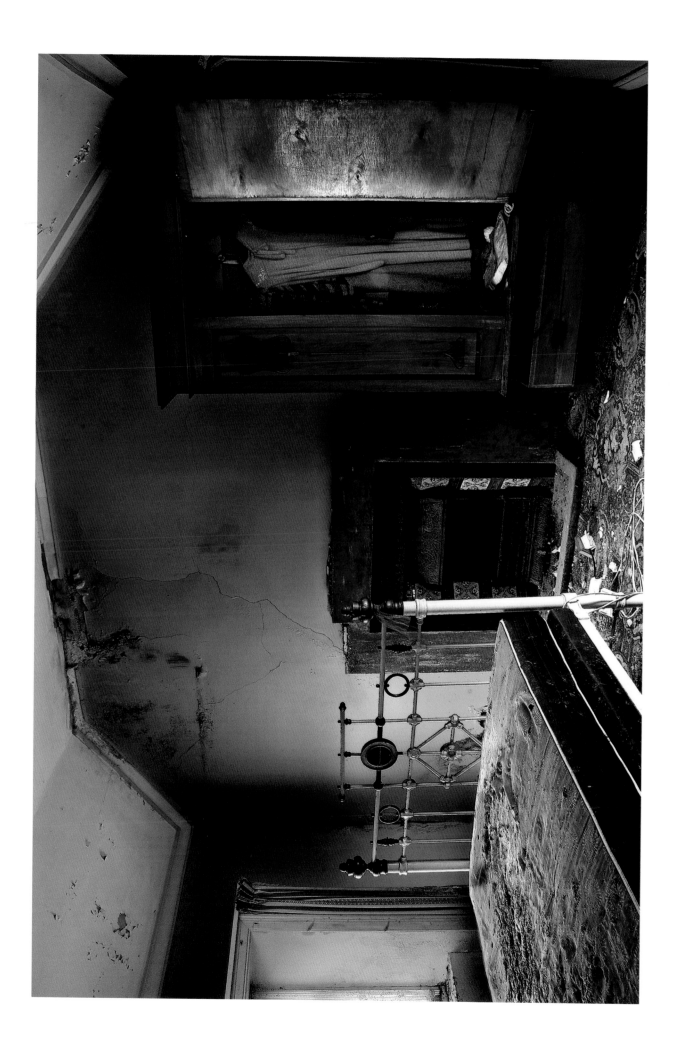

While visiting these unoccupied houses I felt like an intruder disturbing the spirits that still haunt every room. In some homes, it looked as if the last activities were the waking of the dead, the closing of the door and the abandonment of the house. In some cases, a calendar made it possible to date the last occupancy but mostly, the houses were left to the ravages of time. While looking at the scenes about me I felt I was awakening ghosts from my childhood and there were times that the hair stood on the back of my neck as, spurred by dusty, damp newspaper articles or mouldy-framed images, memories came flooding back.

The wallpaper in one room took me back to a holiday home my parents owned forty years ago. An old valve radio reminded me of the thrill of selecting distant cities like London, Luxembourg, Prague on the illuminated dial. I can still hear Radio Éireann playing 'If you feel like singing, do sing an Irish song'.

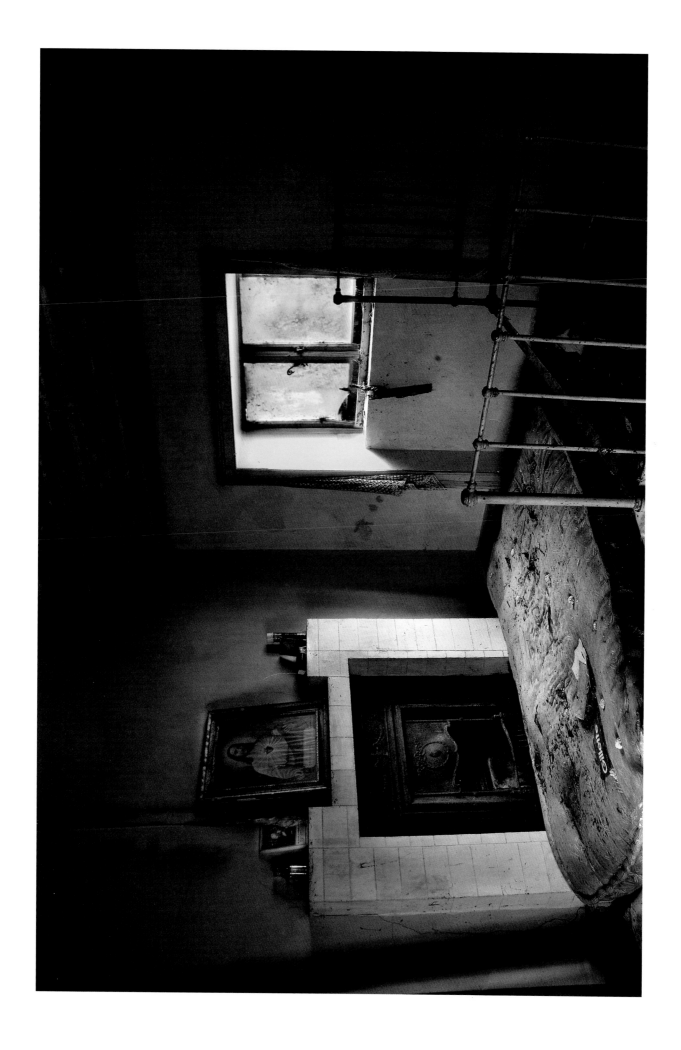

Devotion of the family to the Sacred Heart was widespread in Ireland until the 1960s. A picture of the Sacred Heart was hung in some prominent place in the home and a nightlight burned under it. This was the centre of the family's spiritual life. To this day, pictures of the Sacred Heart with the Papal blessing can be found in Irish homes and evoke a mood of 1950s and 1960s Ireland.

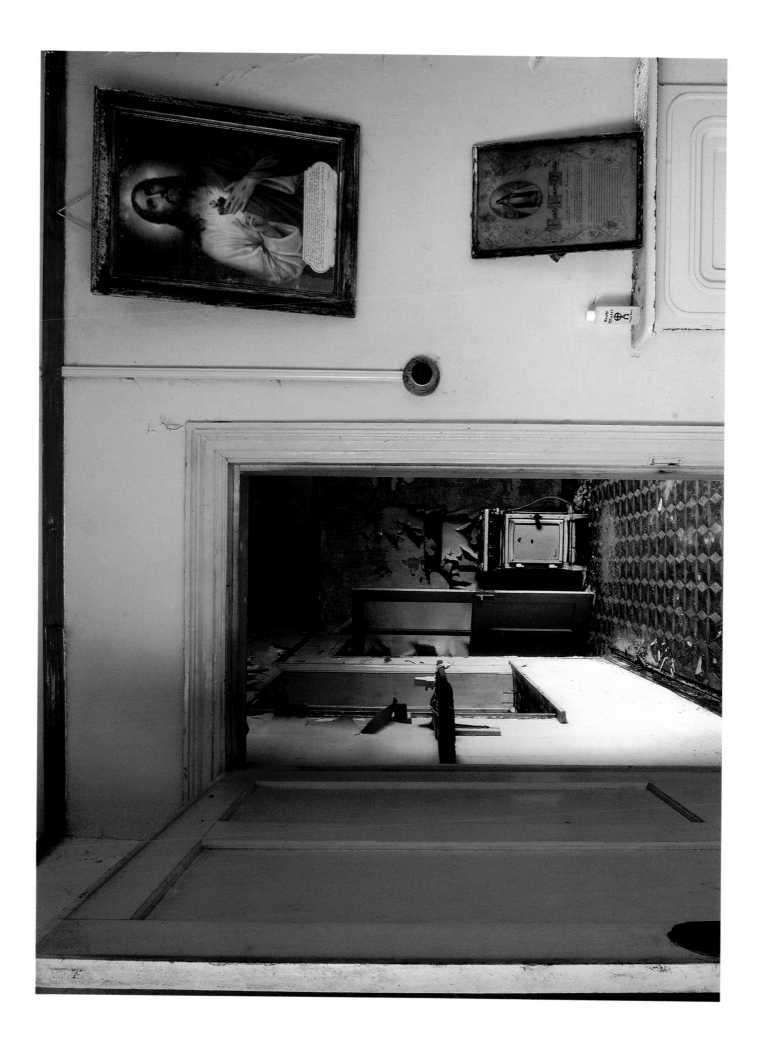

An old dresser is the only piece of furniture left in this kitchen.

The Sacred Heart hangs on the wall and an old clock sits on the mantle.

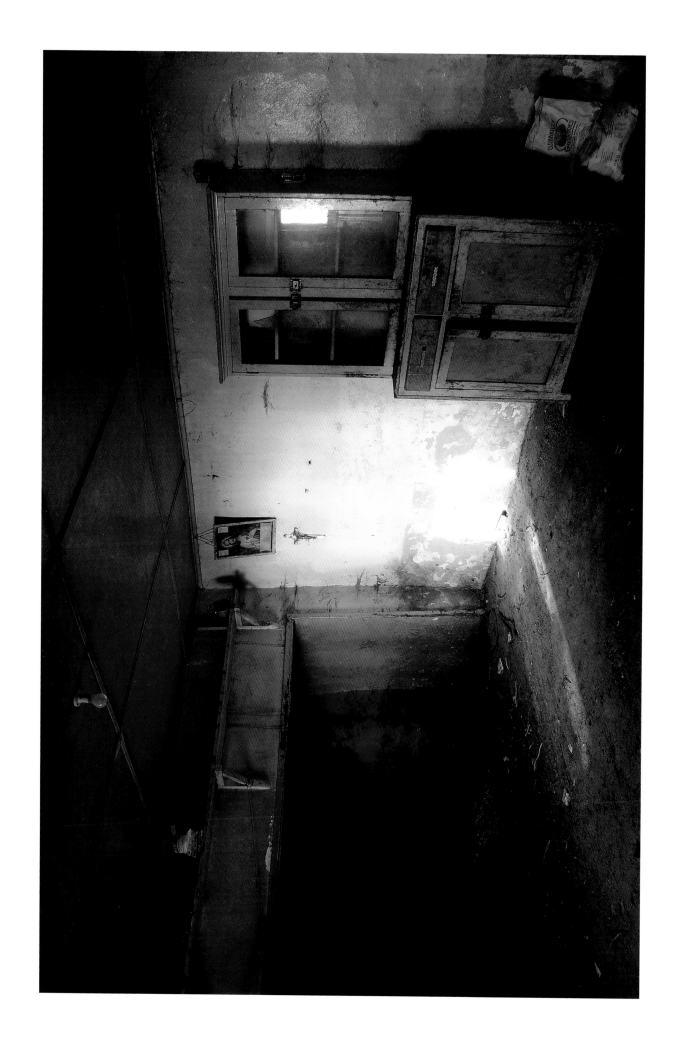

A picture of the Sacred Heart has fallen down on to a table leaving a bare patch on the wall where it once hung.

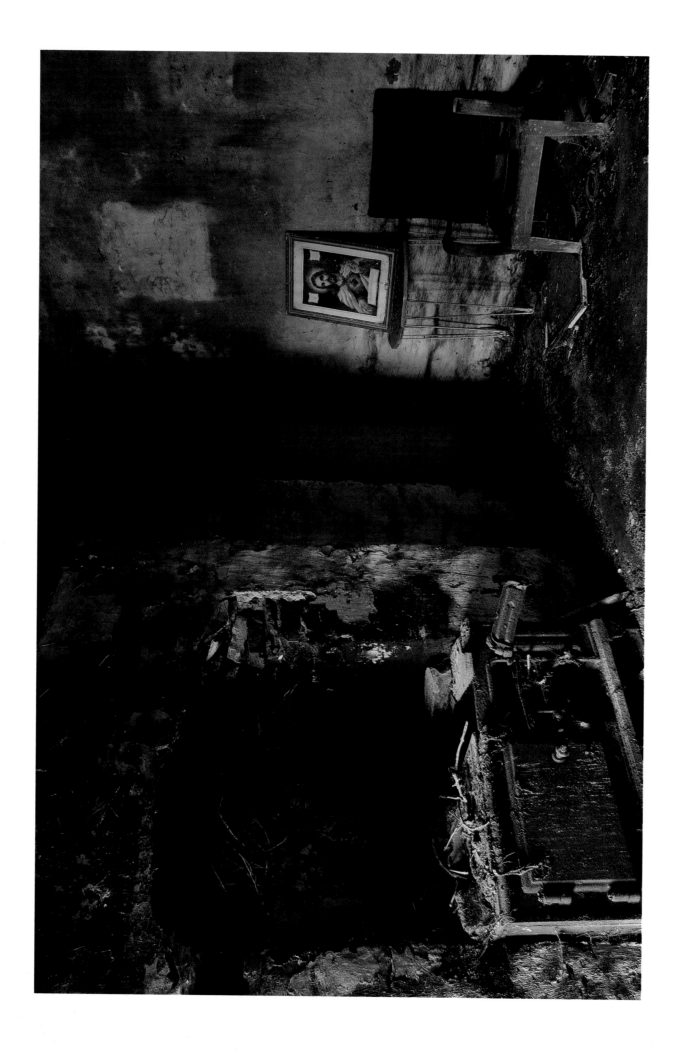

Here a crucifix and Sacred Heart picture hang side by side.

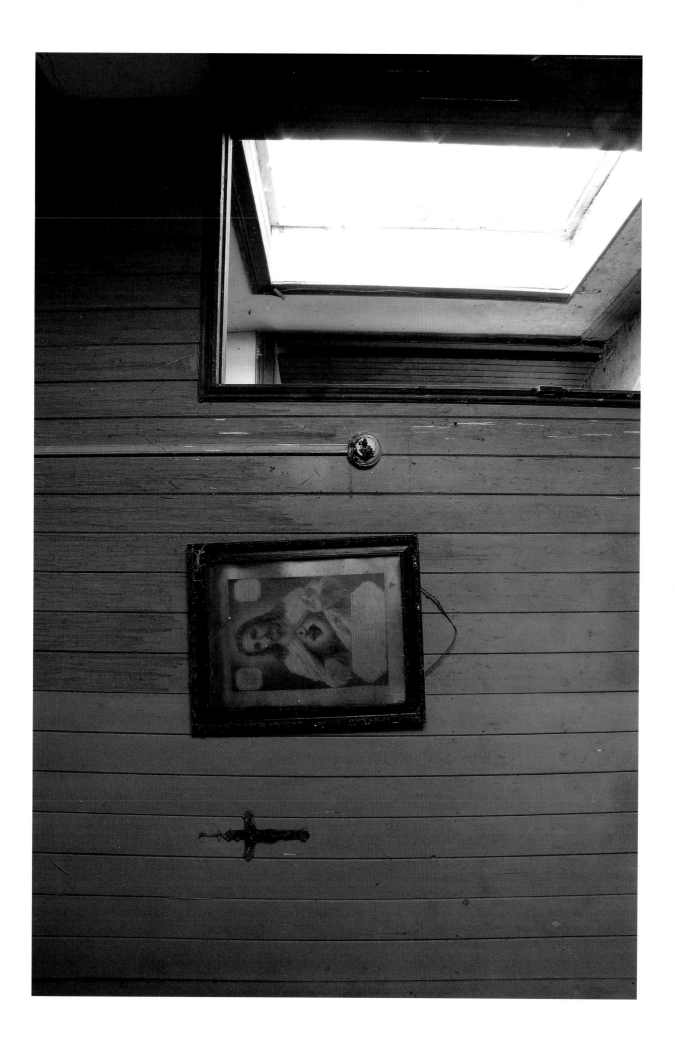

The Sacred Heart hangs over a fireplace, on the mantelpiece is a bottle of pills, a picture of the crucifixion and an Eveready battery. Around the fireside is a set of tongs and a shovel.

The Feast of the Sacred Heart is celebrated nineteen days after Pentecost. The Enthronement of the Sacred Heart is a ceremony in which a priest or head of a house consecrates members of the household to the Sacred Heart. A blessed image of the Sacred Heart, either a statue or a picture, is then placed in the home to serve as a constant reminder to the household of their devotion to the Sacred Heart.

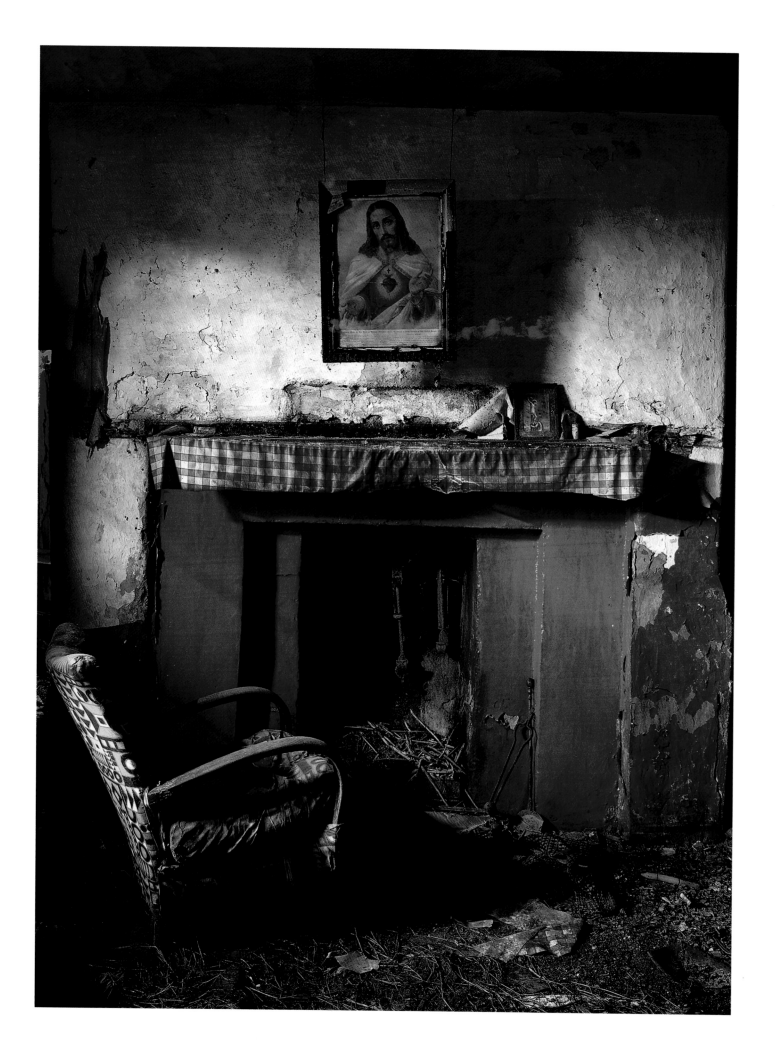

An old bike propped up against a wall
under a picture of the Sacred Heart.
The bicycle still has its pump attached.

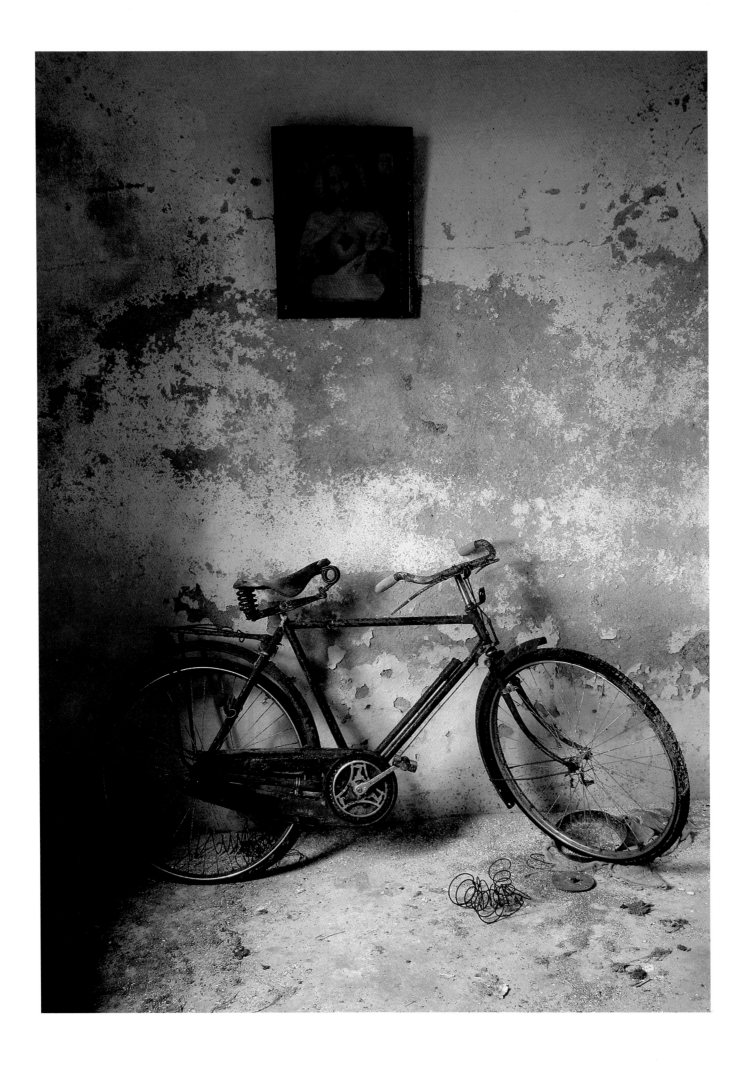

The Suzuki FR 80 scooter was manufactured from the early 1970s and was powered by a 80cc, 2 stroke, air cooled, single cylinder engine that incorporated a self mixing system so it had a separate 2 stroke oil tank and petrol tank. It is started by a kick-start mechanism that turned over the engine. I found this scooter in an old farmhouse in west Cork.

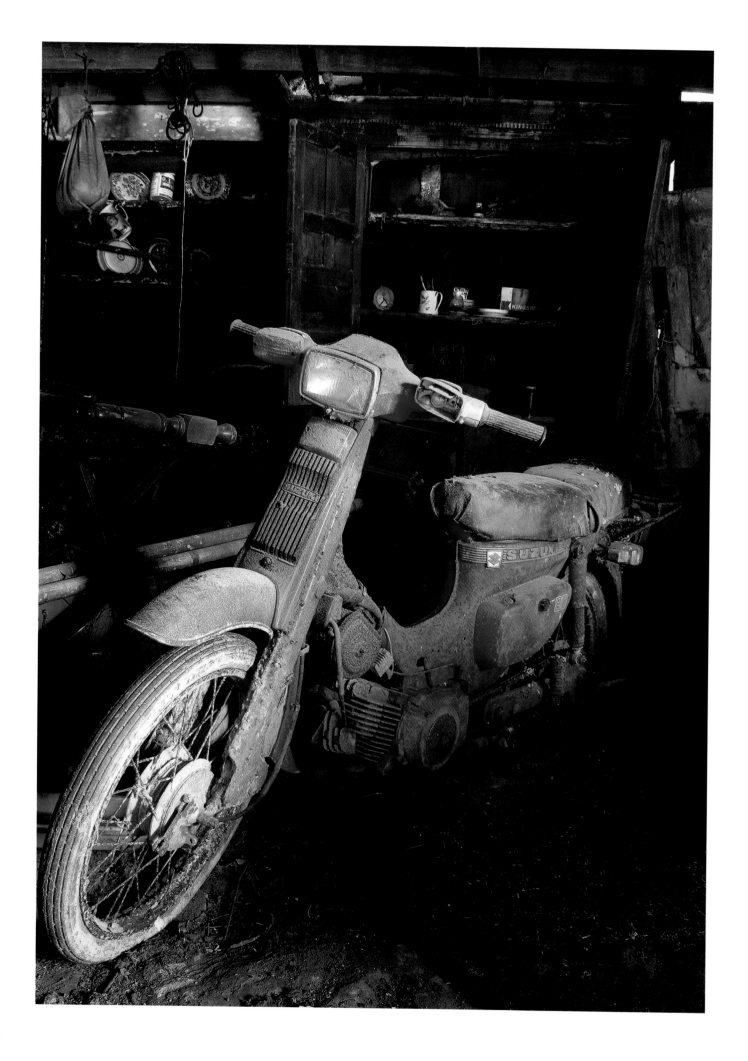

An old saddle and frame of a bicycle lit by a nearby window. The saddle has the name Olympic stamped on it.

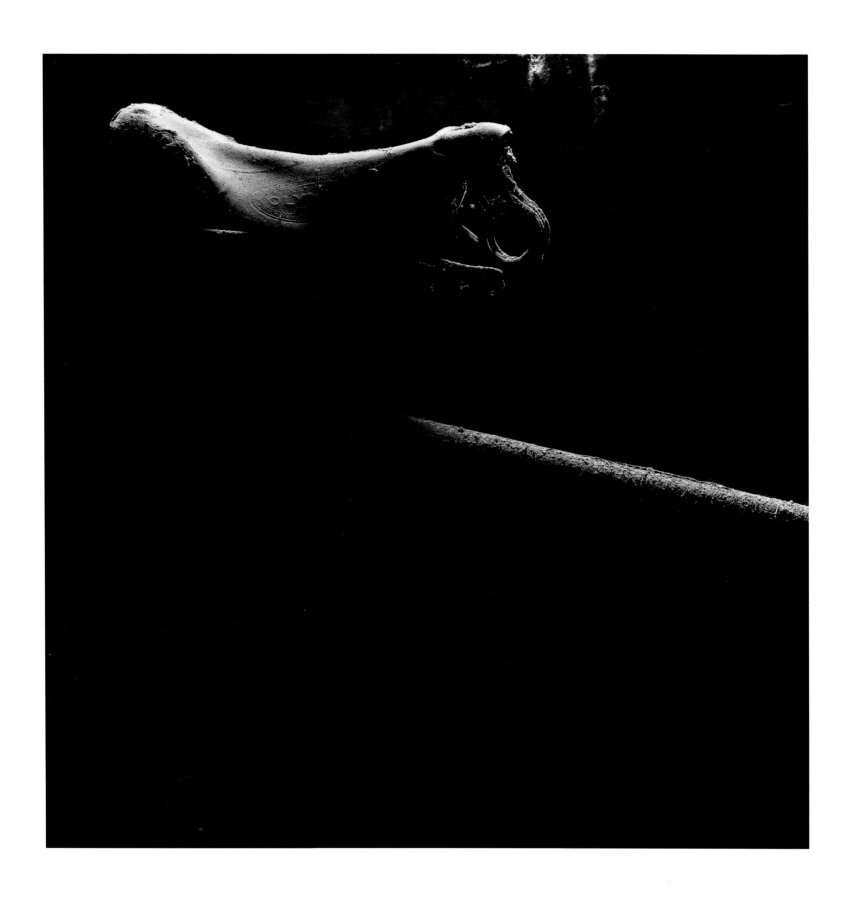

The Ferguson Tractor Model TE20 was commonly known as the Little Grey Fergie. Production started in the late summer of 1946 and continued until 1956. The Ferguson TE20 was the first tractor to be produced by Harry Ferguson in the UK and manufactured at the Banner Lane factory in Coventry. Early versions of this model ran on petrol but the version here has a diesel engine.

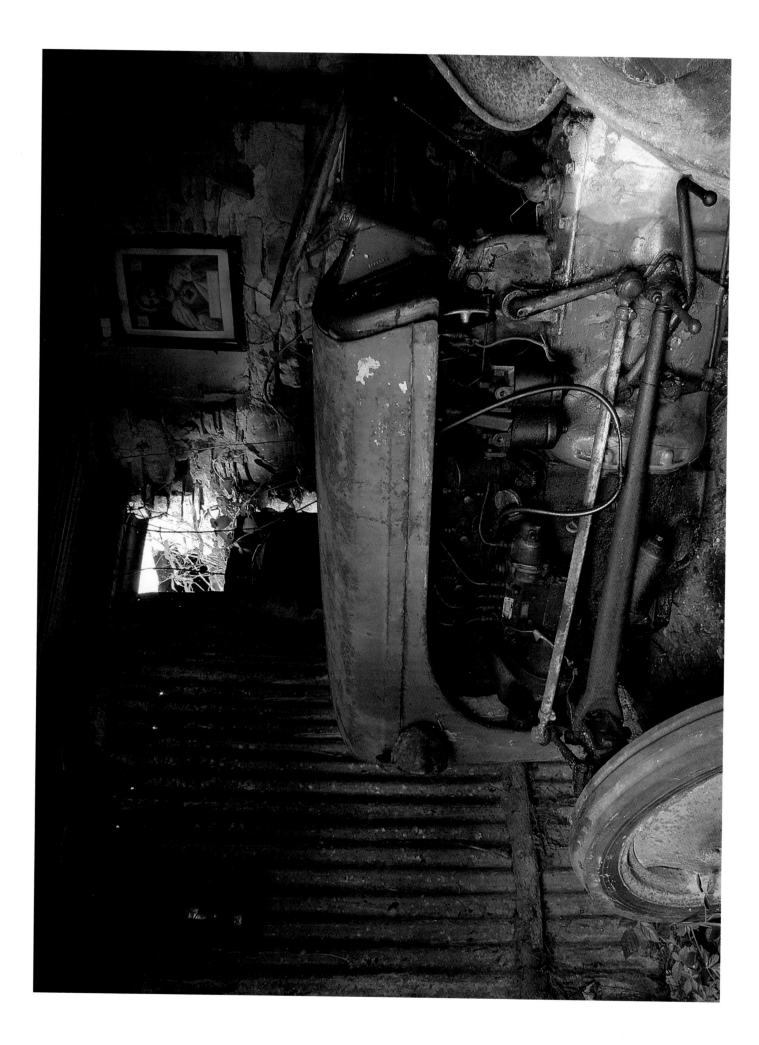

A Ford Consul car safely tucked away in a garage, probably in good condition at the time but then left to decay. Where were the relatives who could have used it? Was emigration or illness responsible for its abandonment?
This car was probably assembled at the Ford Plant in Cork. Ford was one of city's biggest employers. The plant was built in 1917 and by 1930, when the population of Cork was approximately 80,000, Ford employed 7,000 workers. The factory closed in 1984 and production was transferred to England.

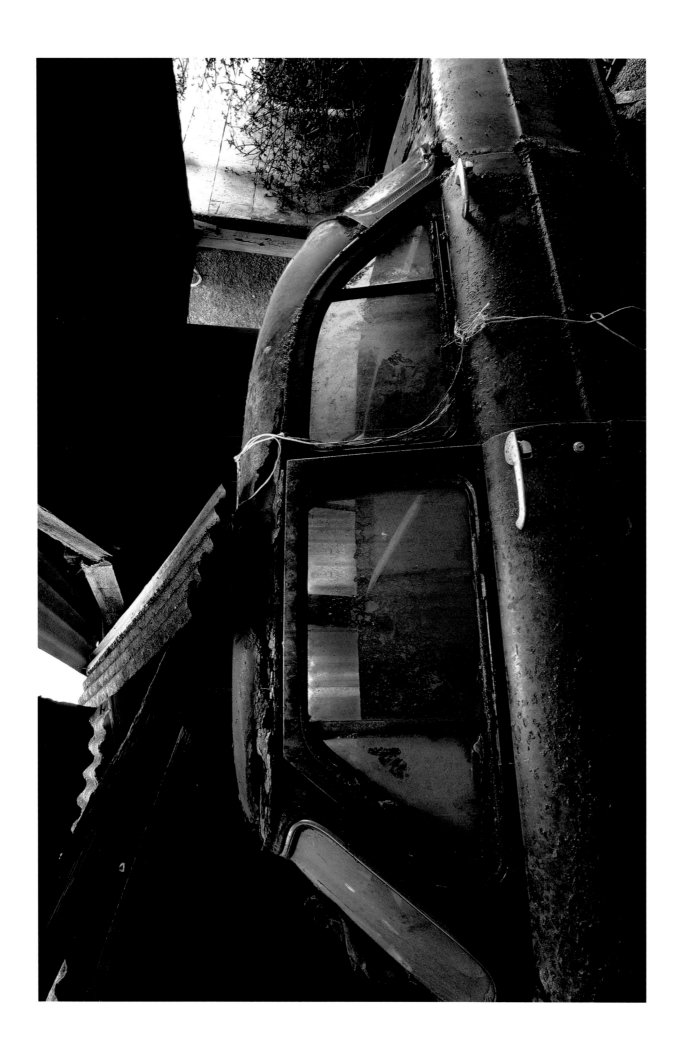

Two pair of boots lie in a kitchen in County Kerry. A horseshoe has been nailed to the heel of one the booths to prevent wear.

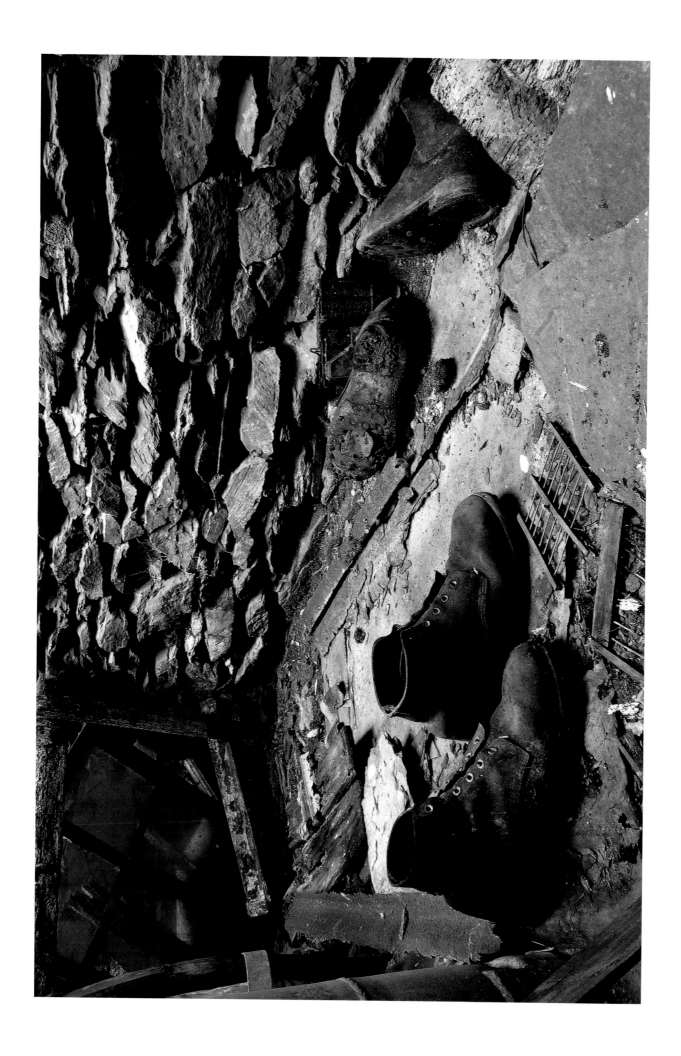

A pair of old boots, covered in cobwebs, lie undisturbed on a kitchen floor.

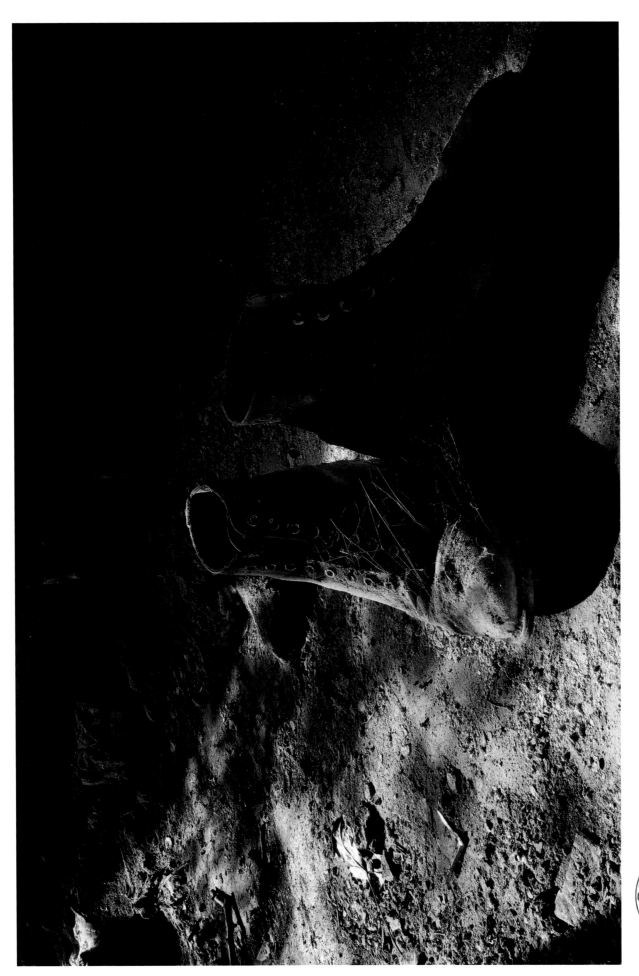

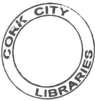

This old suit jacket was left hanging in a wardrobe in west Cork; it had seen better days. The left sleeve now has a hole and to the left is a crucifix hanging from a nail. In our house it was the norm for us to get dressed up in our Sunday best for mass or other special occasions.

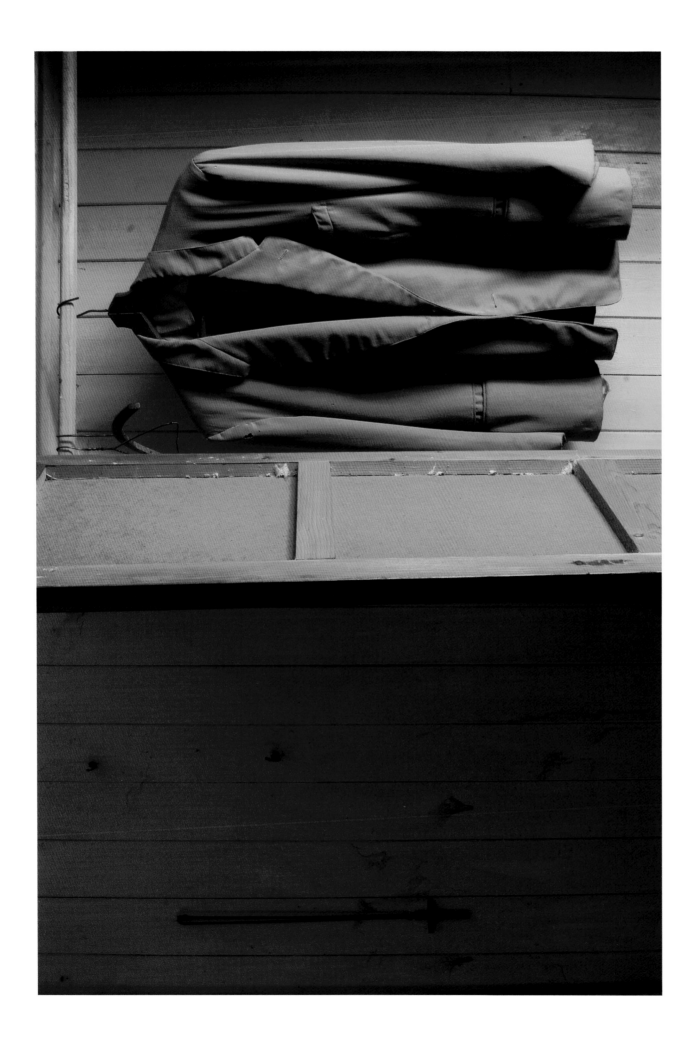

An old pram lies next to a picture of the Saviour. The house is empty now and the laughter and cries of the children are long gone.

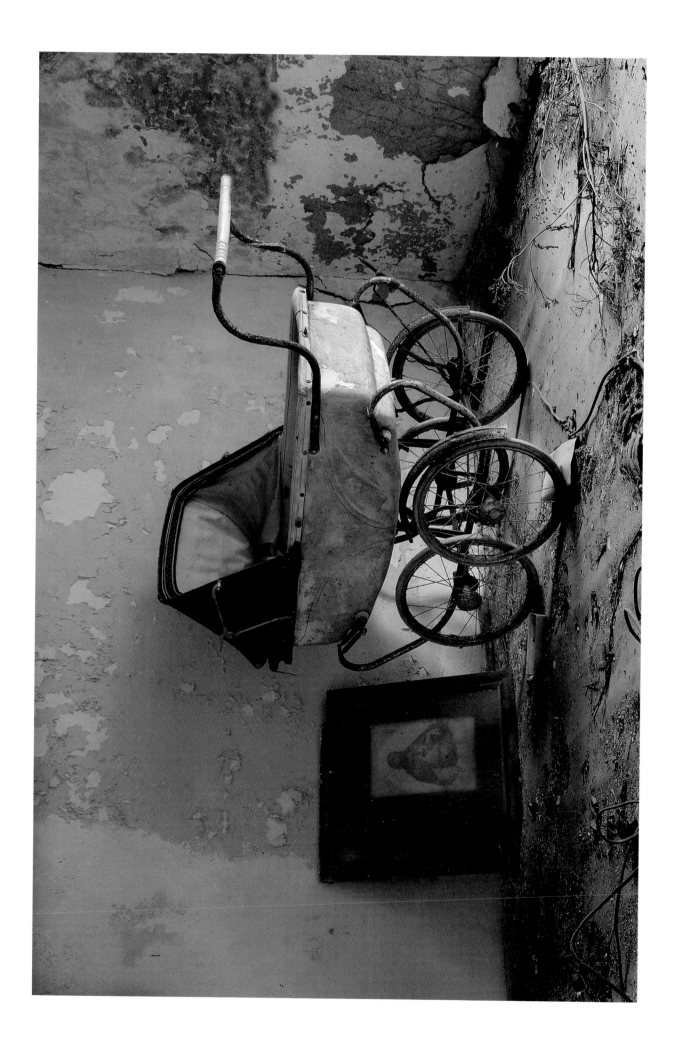

In modern society everything has become disposable but in the 1950s and 1960s a Singer sewing machine could be found in many homes. Those who had moved away often sent parcels of clothes home from America and elsewhere and the machine would have been put to good use in altering garments.

I can still remember my mother surrounded by patterns, all laid out on the floor at home as she cut and sewed clothes for the family or maybe for some forthcoming event like a dance.

The Singer sewing machine company was established in 1851 and set up its first factory in New York in 1863. It went on to be one of the most successful sewing machine companies in the world.

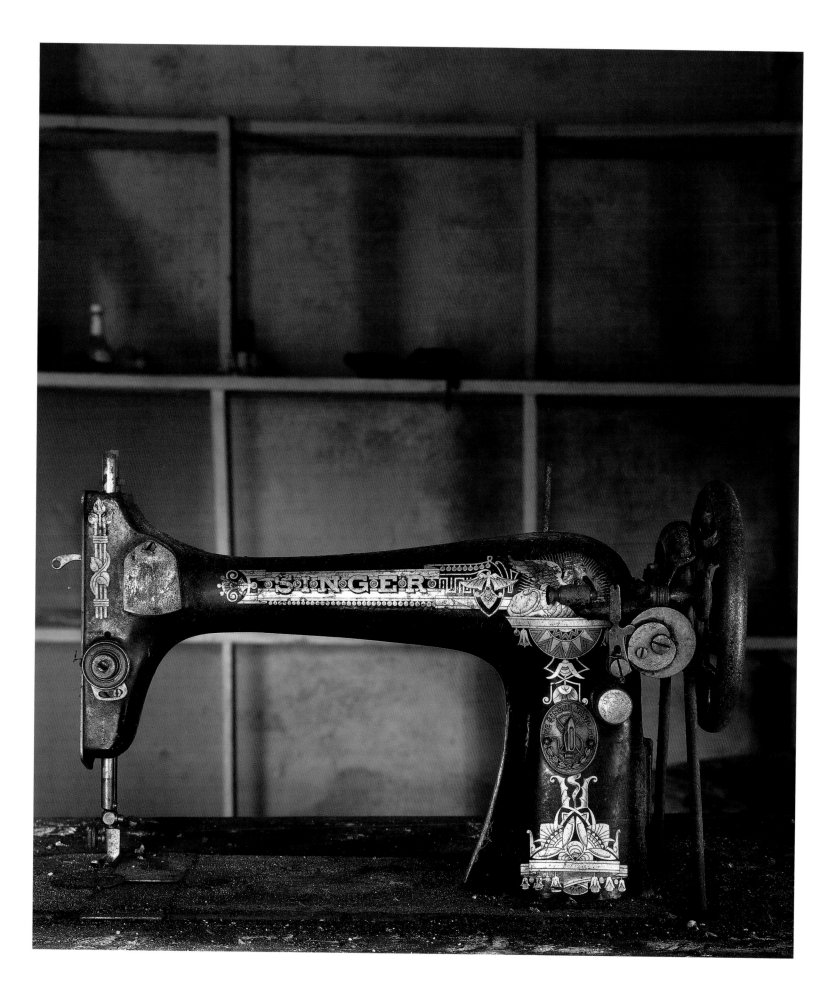

Ornate decoration on a Singer sewing machine.

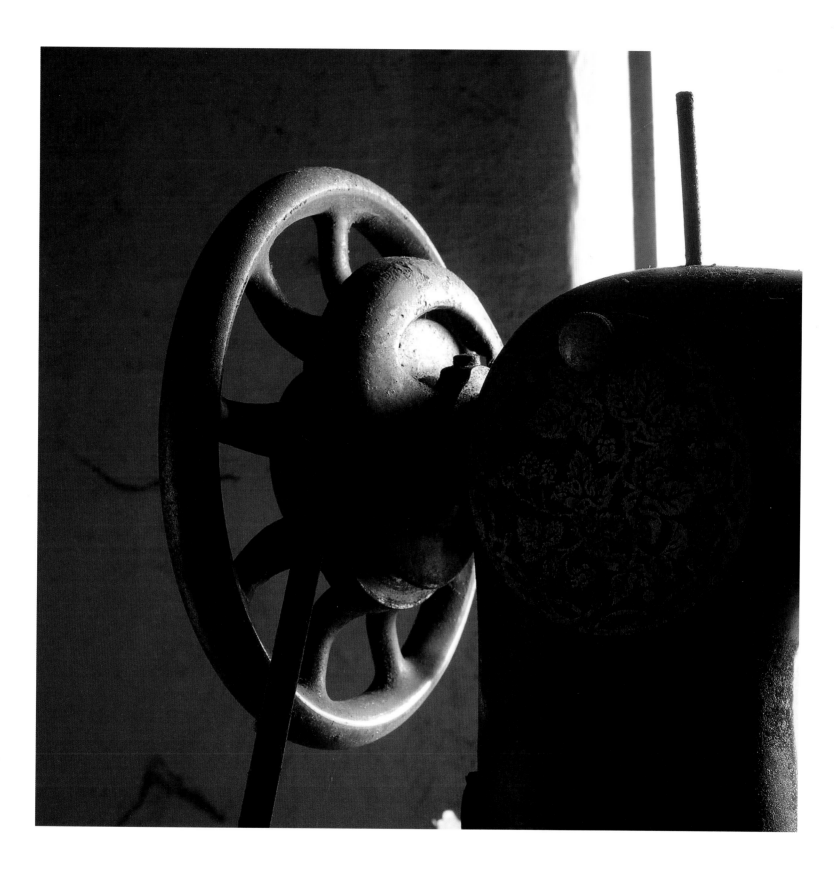

A Singer sewing machine in an old shop.
The Irish Press calendar on the wall
is dated 1964.

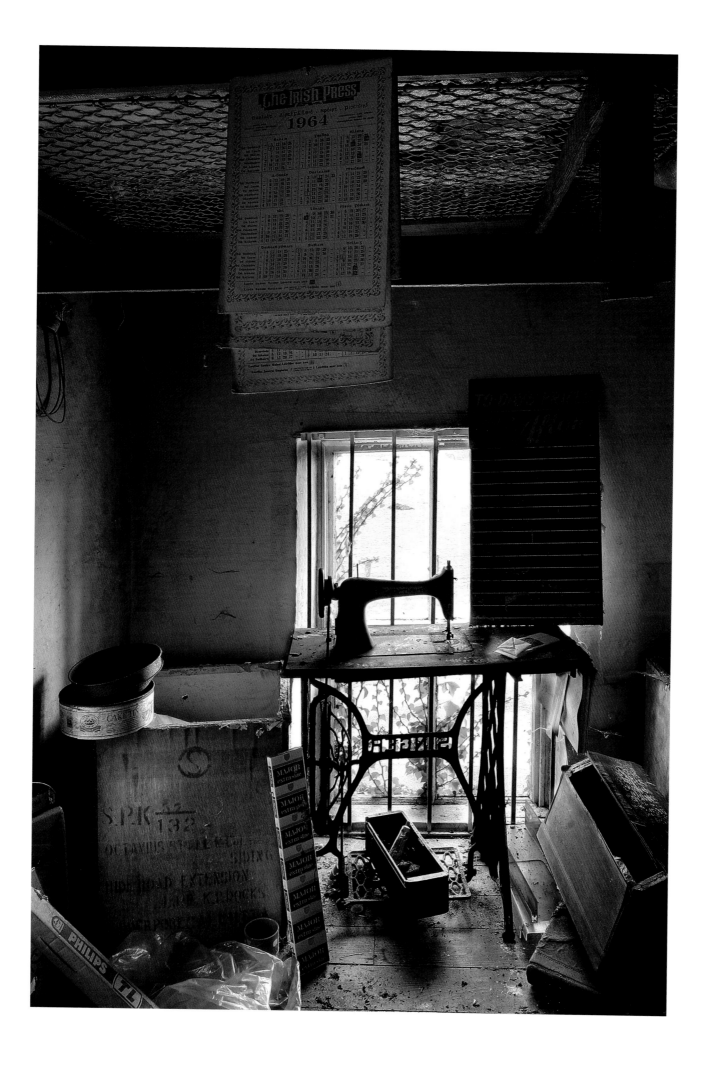

A bacon slicer has been left in this old shop and on the counter are copies of the *Sunday Independent*. Hanging on the wall is a picture of the Sacred Heart and a calendar dated 1997. On the chair is a tattie hat while on the ceiling there are hooks for hanging gammons at Christmas.

With emigration opportunities plentiful there was a significant drop in those employed in agriculture. Figures from the Central Statistics Office show that between 1951 and 1961, 115,000 left Ireland while job losses in industry and services are put at 48,000. The counties with the highest levels of emigration in the 1950s were Leitrim, Donegal, Monaghan and Mayo. The effect on the wider community was not only the loss of its people but also the loss of local businesses that were unable to sustain a living. The role of small shops and pubs in communities cannot be underestimated. They provide a vital part of keeping rural communities together and serve as a social outlet for local people to interact and find out what is happening in their community.

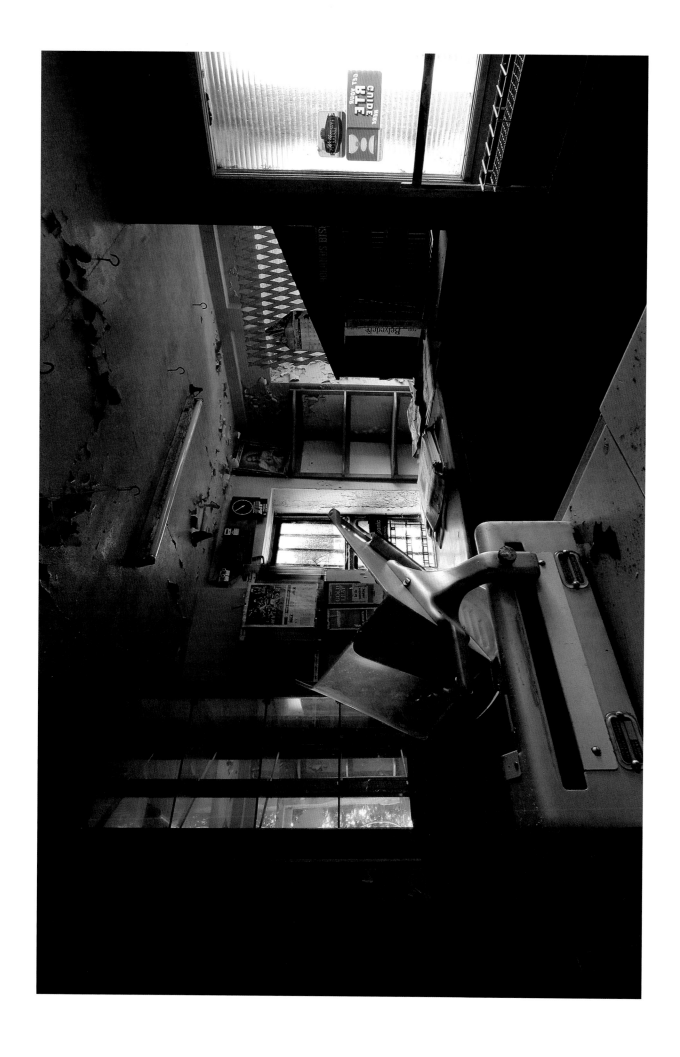

This old rusted Berkel meat slicer is a tabletop machine and was hand operated. Berkel stopped producing meat slicers in the 1960s and these old hand-cranked machines are now hard to find.

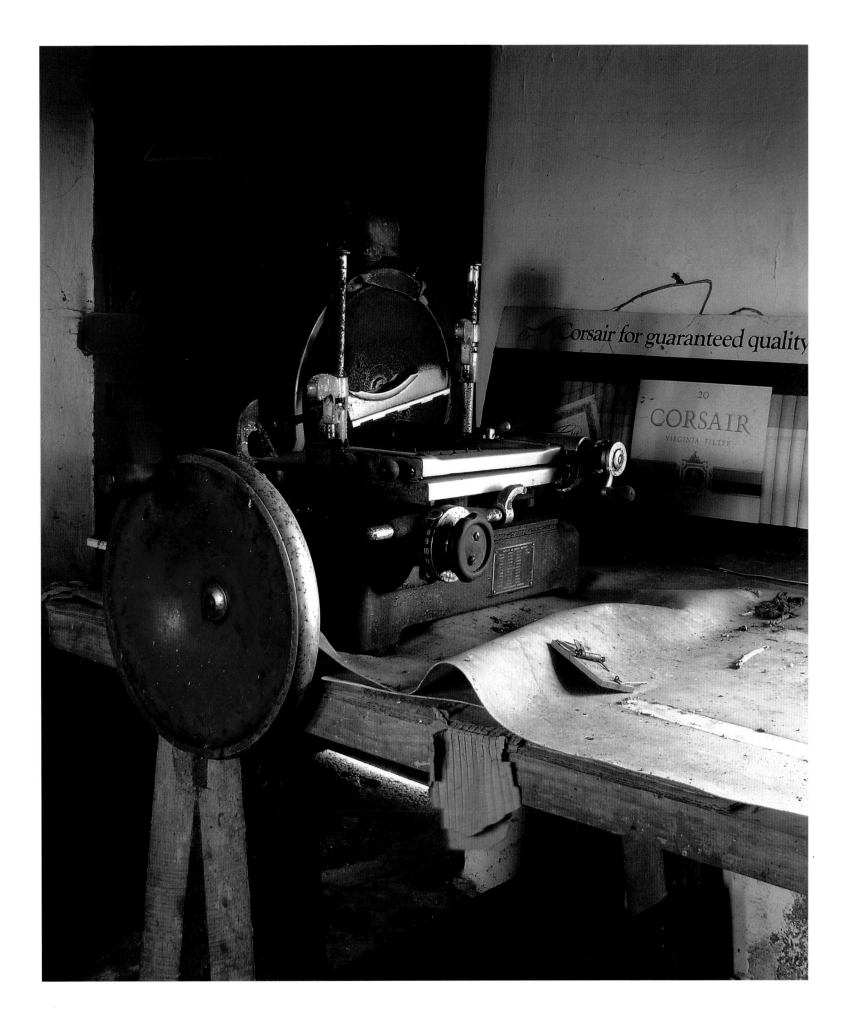

A brightly-coloured public house with a dispenser tap for Murphy's Stout. The tap has the old logo that featured the strongman Eugene Sandow lifting a horse. Sandow became world weight lifting champion in 1891 and the slogan used by the company was 'Murphy's Stout Gives Strength'.

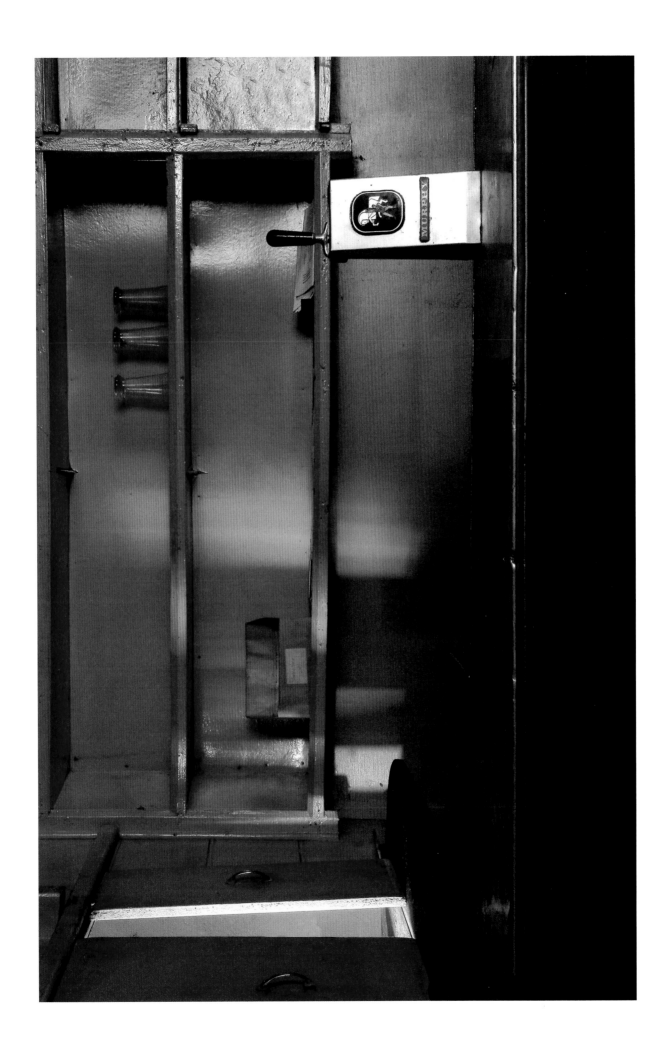

I really felt a presence in this room. Looking at the bed and the indentation on the pillow I got the feeling that someone had passed away here. The chest of drawers has been turned into an altar with candlesticks and a cross.

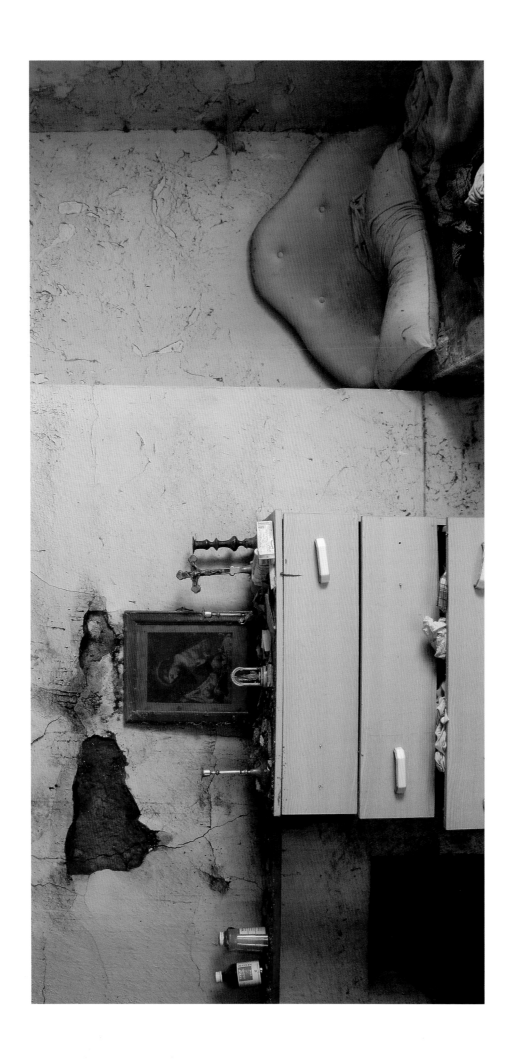

A statue of the Virgin Mary sits on a dresser next to a box of matches. During my time photographing these homes I would regularly come across houses that were empty of contents, except for the religious pictures and statues that remained untouched.

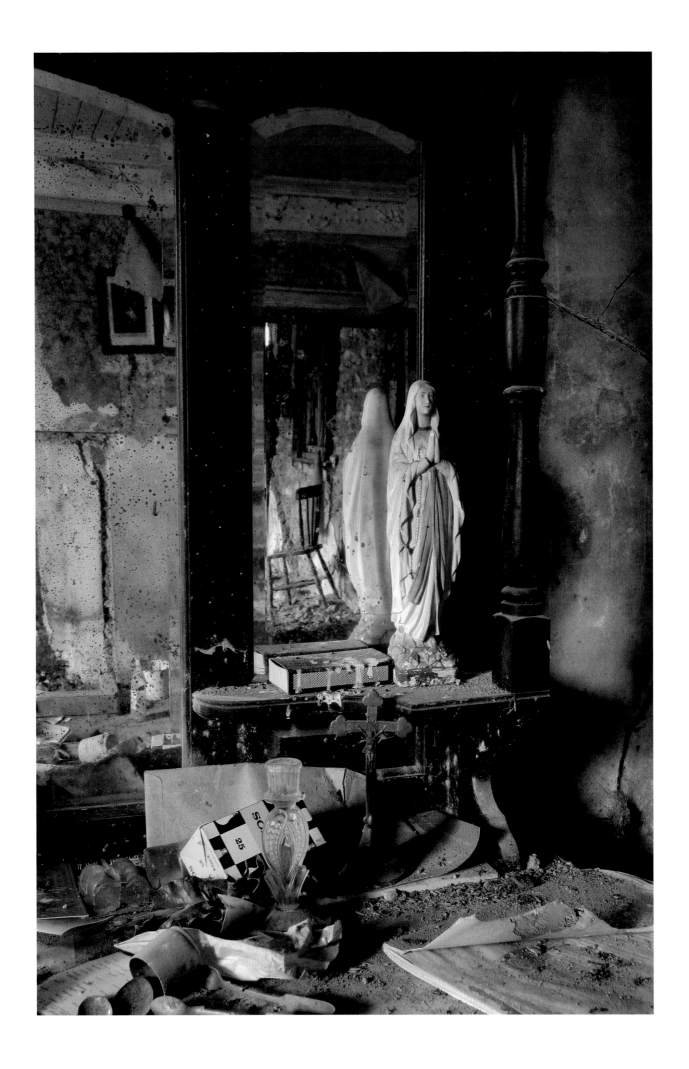

Here a picture of the Virgin Mary lies on the floor behind the door, almost as if someone took it from the wall, intending to take it with them and then forgot.

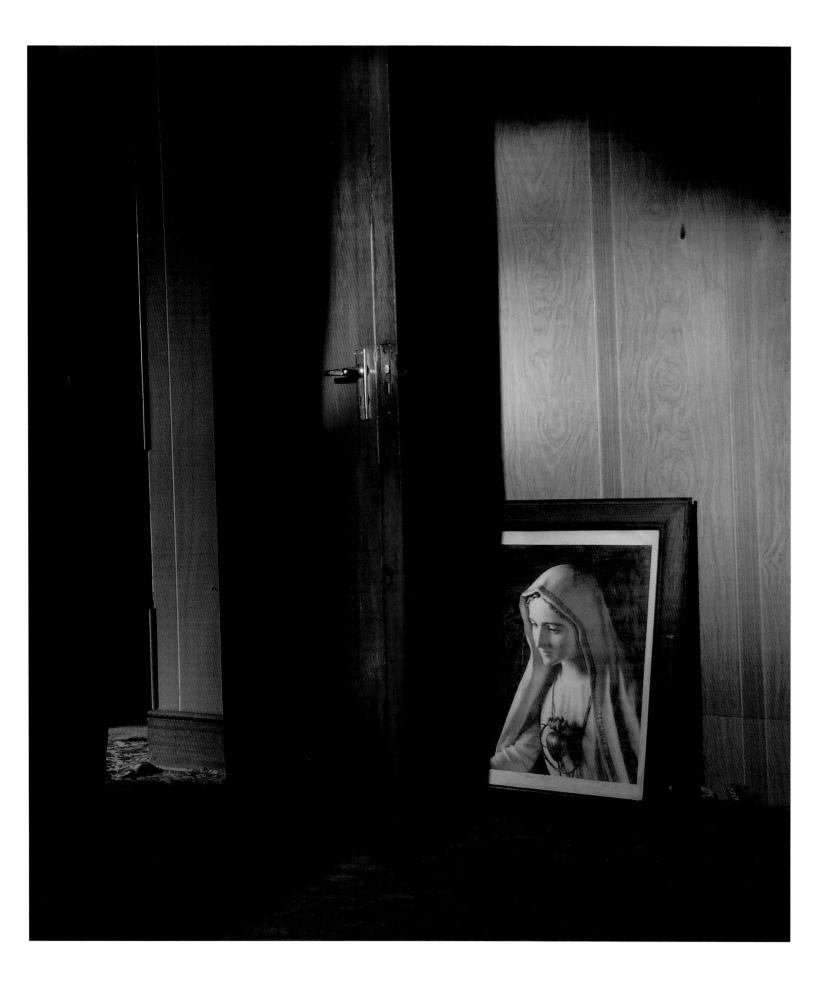

An airmail letter from America stamped 'Fosterdale NY 16th August 1974' sits on a mantelpiece next to old photographs. The woman is in a dress and hat, which suggest the photograph may have been taken in the 1930s, while the man is dressed in what appears to be an American military uniform. Could these be relatives perhaps? In the letter, the writer states, 'I suppose I'll never make it home now to the old sod. I'll always be an exile.'

Unlike today, letters were an important way for families to keep in touch with loved ones abroad. They may also have contained money which families were dependent on in order to survive.

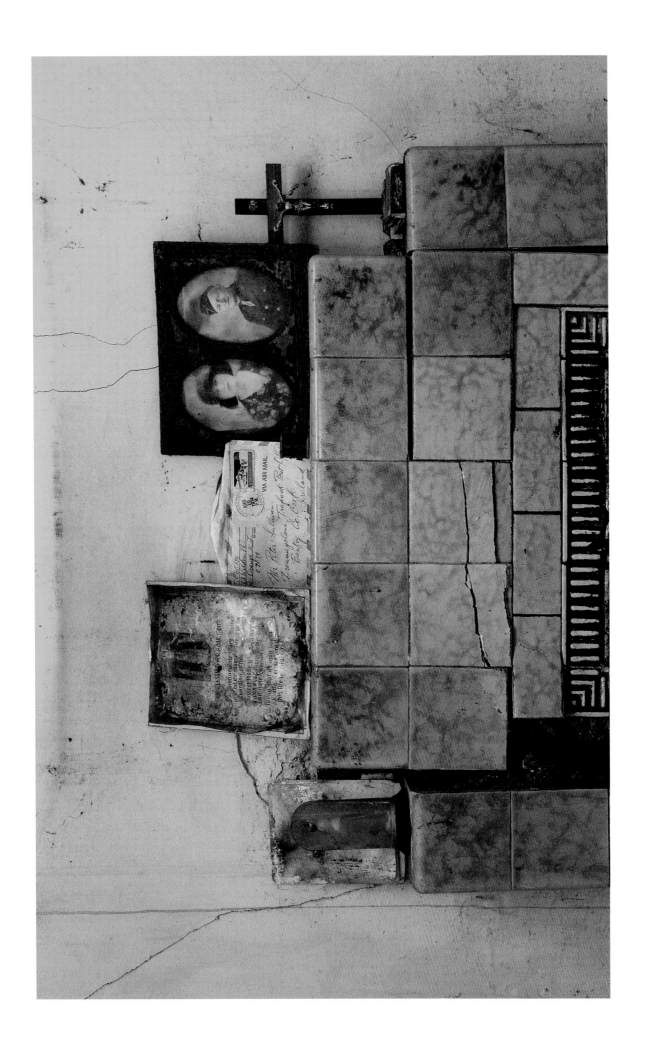

There are music manuscripts lying on the bed and in another room there was a piano as well as diplomas from the Royal College of Music London dated 1903.

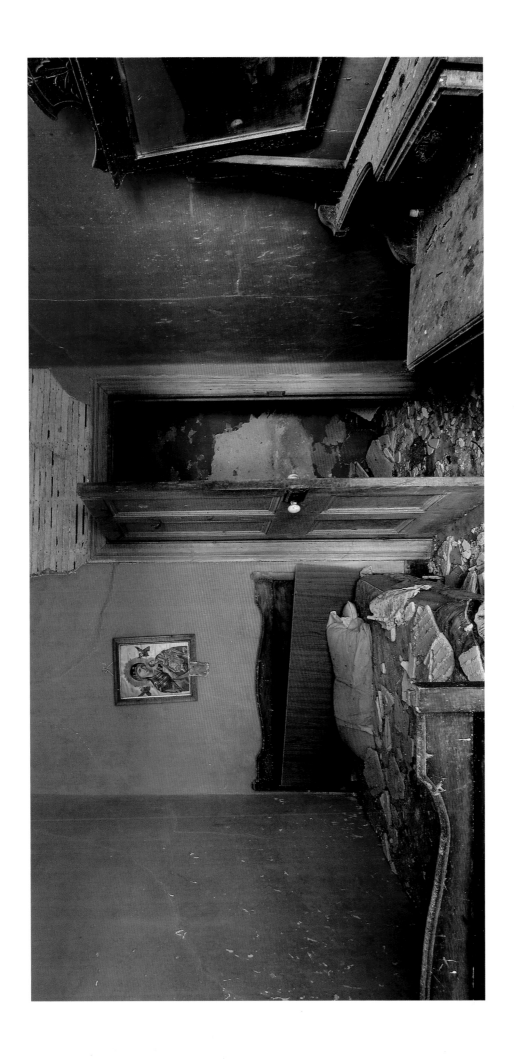

A collection of family and holy pictures sit on top of a dresser in a house in the west of Ireland. The calendar, dated November 1982, is titled 'Salesians of Don Bosco'.

In 1859 John Bosco founded the order of the Salesians of Don Bosco in Italy, primarily to help care for young and poor children of the industrial revolution. A night school was established for boys and from this other schools were opened. The order grew rapidly and expanded into Austria, Britain and Spain as well as South America. In the first decade of the twentieth century the order had spread to China, India, South Africa and the United States.

In 1919 the order established itself in Ireland in Pallaskenry, County Limerick. They have expanded throughout the country and continue to work with young people. Today the Salesian Society numbers almost 16,000 members who work for young people in 130 countries.

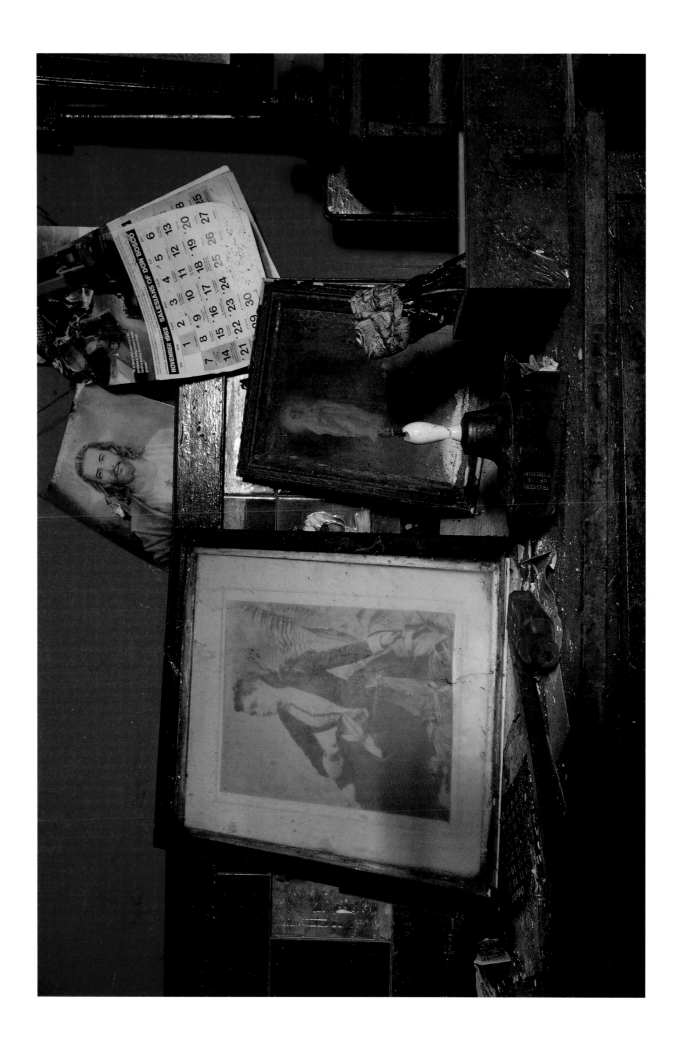

In one house, I found this thimble, an item usually found in every lady's sewing box. But here it has been abandoned, although it does not even look tarnished.

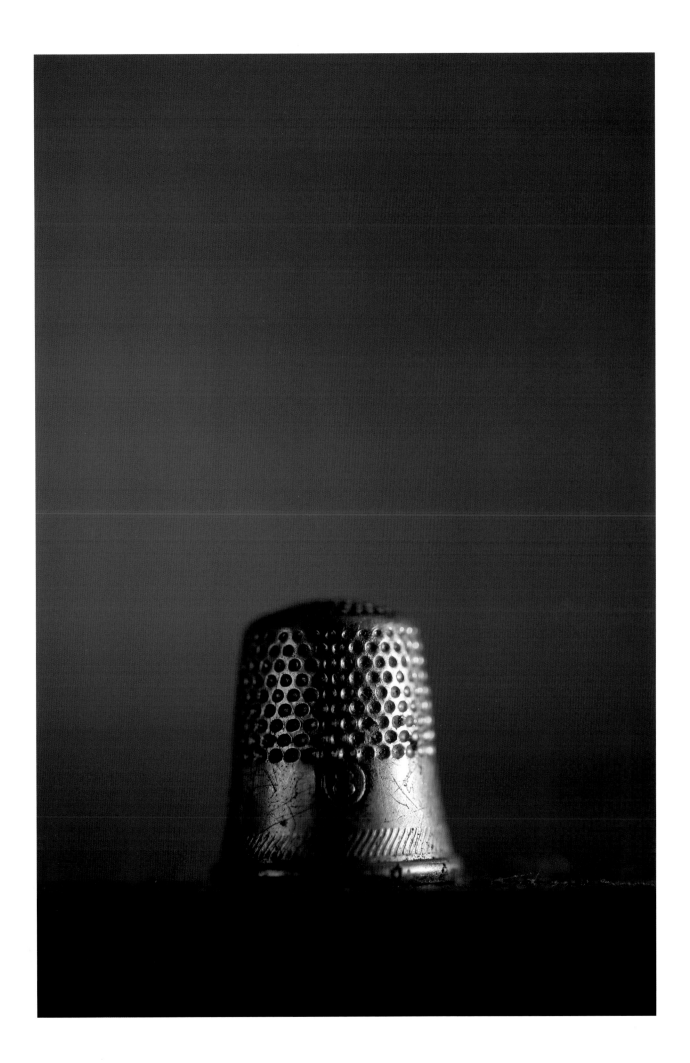

A kettle on a crane in an old farmhouse.

You can almost hear the songs that would have been played on this old Steinbeck piano, almost see the family gathered around. Now this relic is forgotten and falling apart.

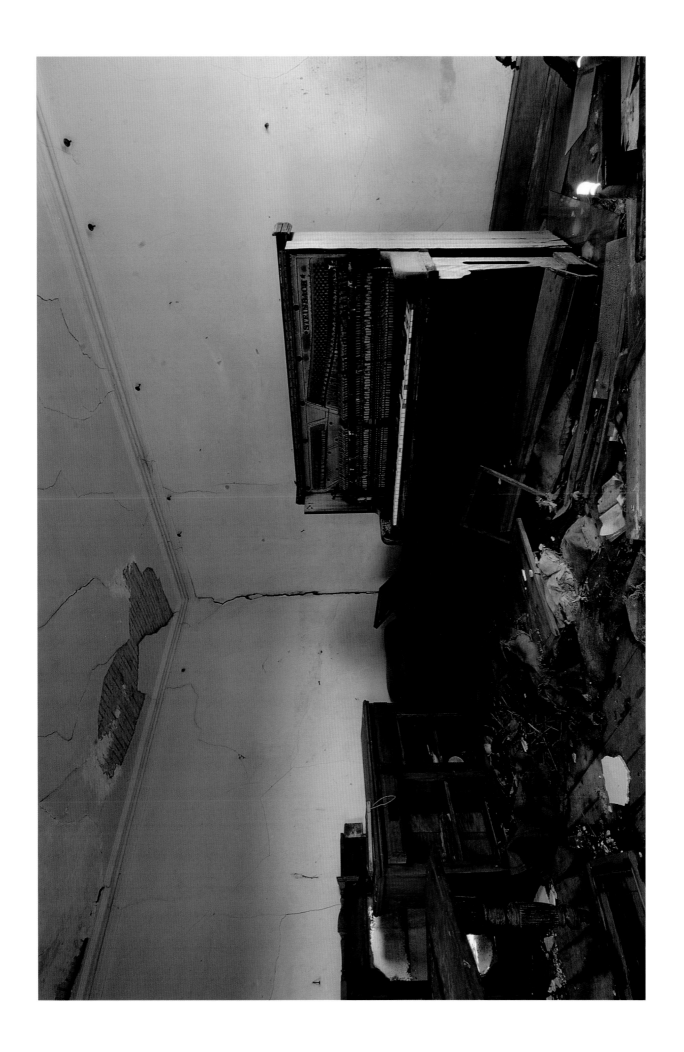

In this bedroom I found a gramophone that had seen better days. On the dressing table is a cash box and a bank of Ireland cheque for £1.00.

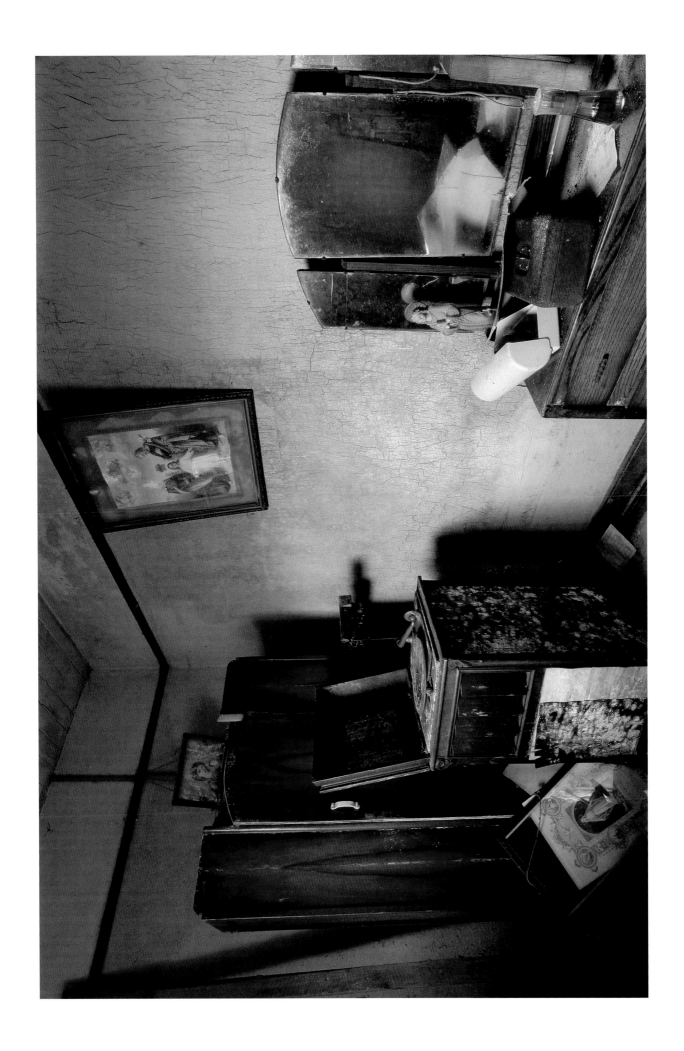

The gramophone is a Columbia Grafonola 75 and probably dates from around the 1920s. The base consists of two compartments: the top has four music vents that open and close while the bottom has storage for six 78 rpm records.

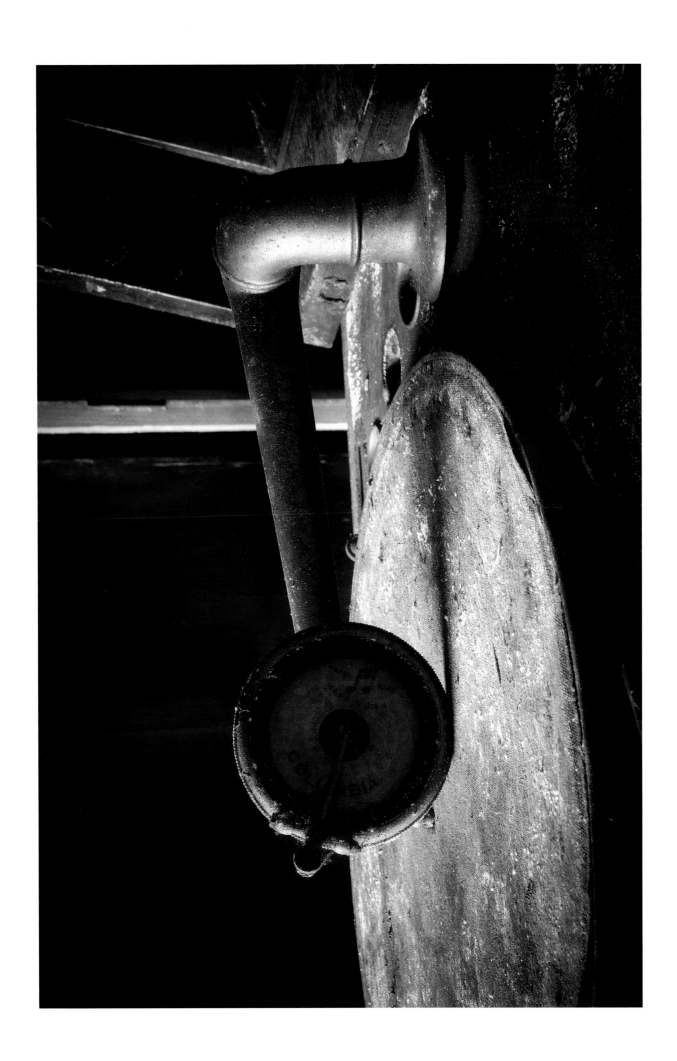

Housework may not be easy these days but imagine ironing clothes for a whole family without the benefit of electricity.

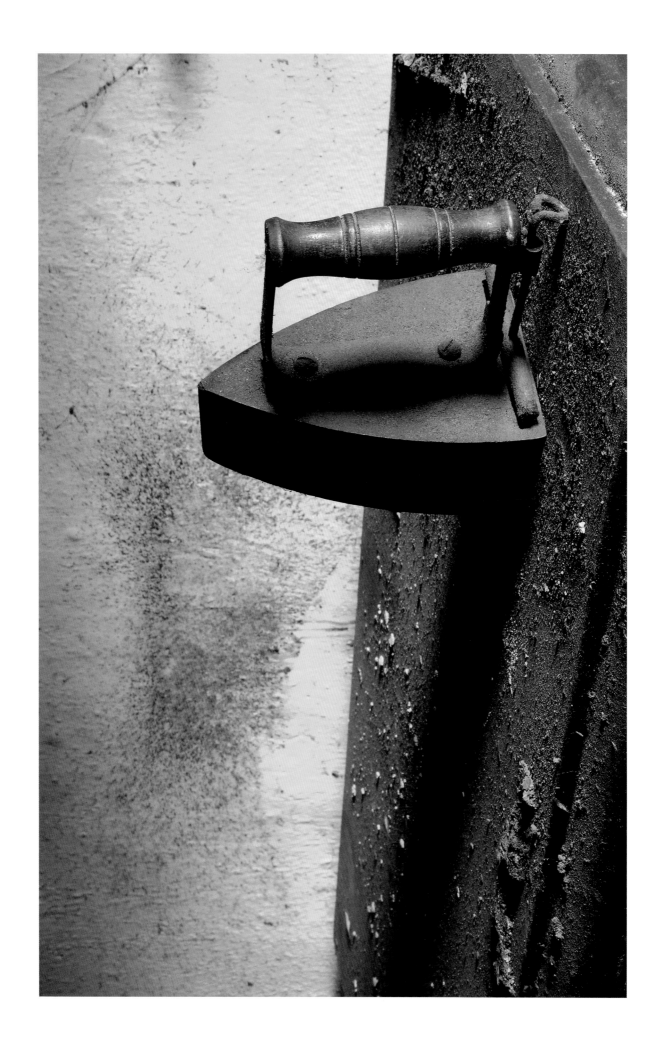

This old-style shaving brush was probably made of badger hair and while modern electric razors have been popular, some say this modest brush is making a bit of a comeback.

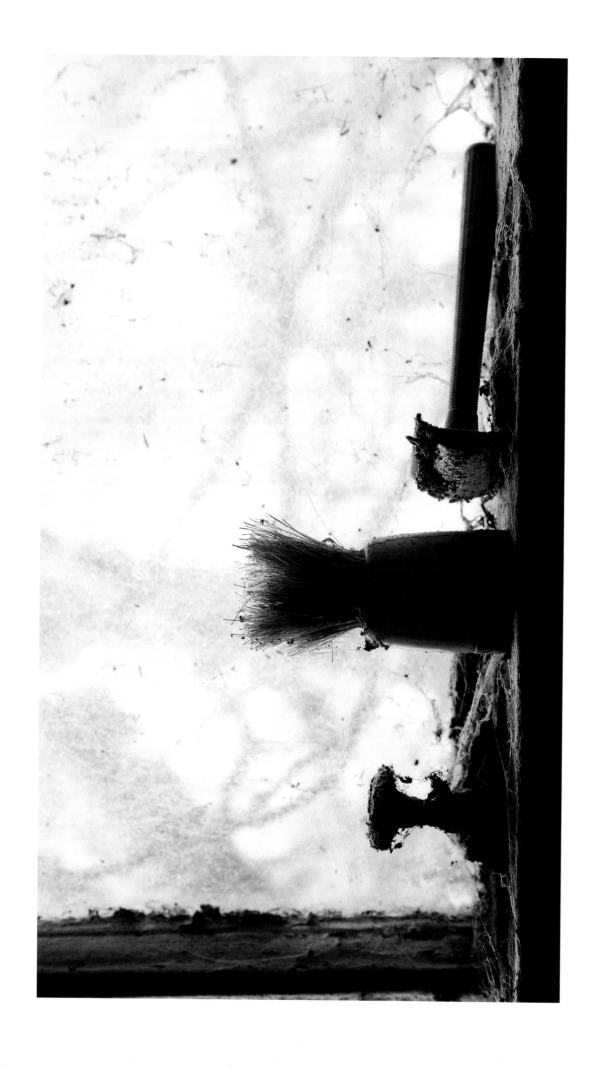

The Primus was always a handy back up in case of a power cut.

I remember we had two in our house that were called into service on a number of occasions.

The last time we used it was in 1977 during a camping trip to Kerry and while we were cooking the sausages, the paraffin leaked and ignited, setting our tent on fire.

The original stove was developed in Sweden in 1892 by Frans Wilhelm Lindqvist and quickly earned a reputation as a reliable and durable stove in everyday use and it performed especially well under adverse conditions.

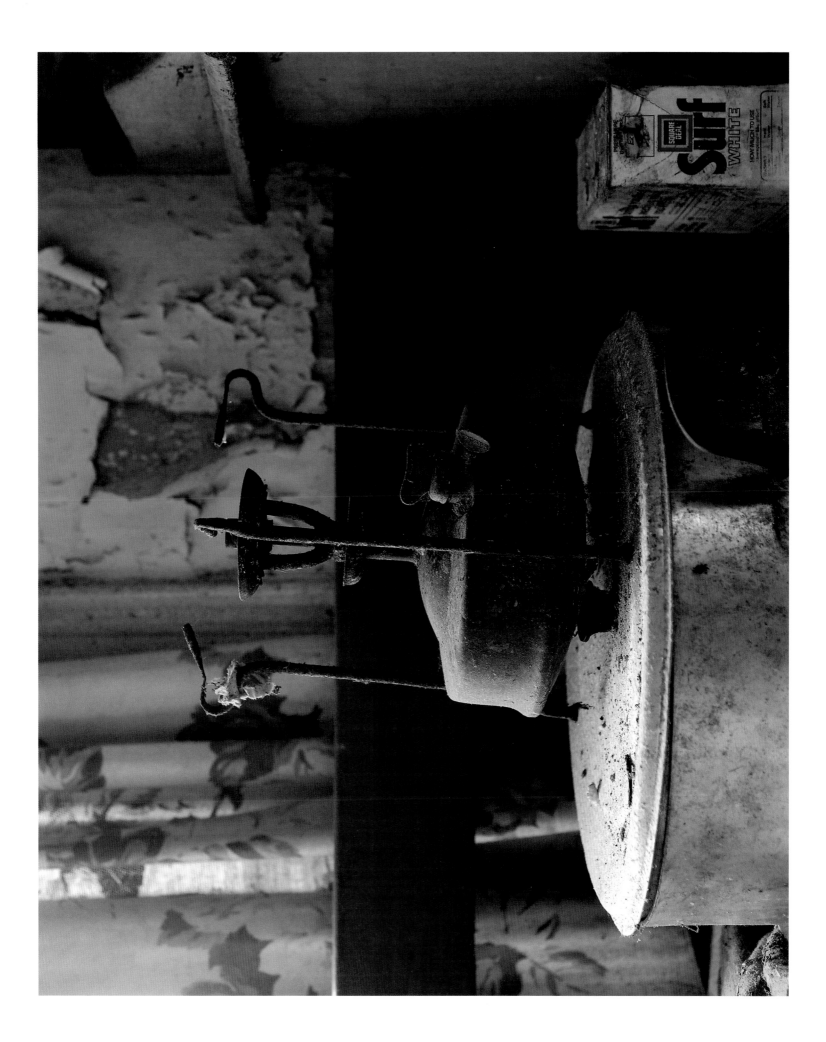

Today hats can be practical, fashionable or sporty but in the past, hats were worn as a mark of respect for others but also to keep your head warm. Most people would have had a working hat for everyday use and a 'Sunday best' hat.

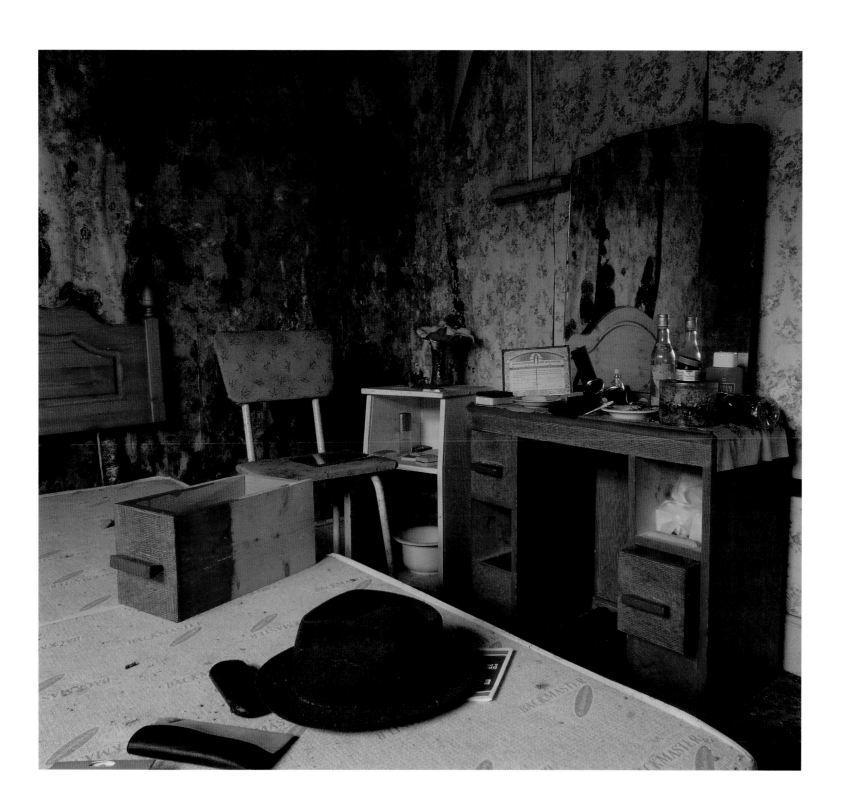

This pretty lady's hat was probably worn to attend Mass on a Sunday morning and other special occasions.

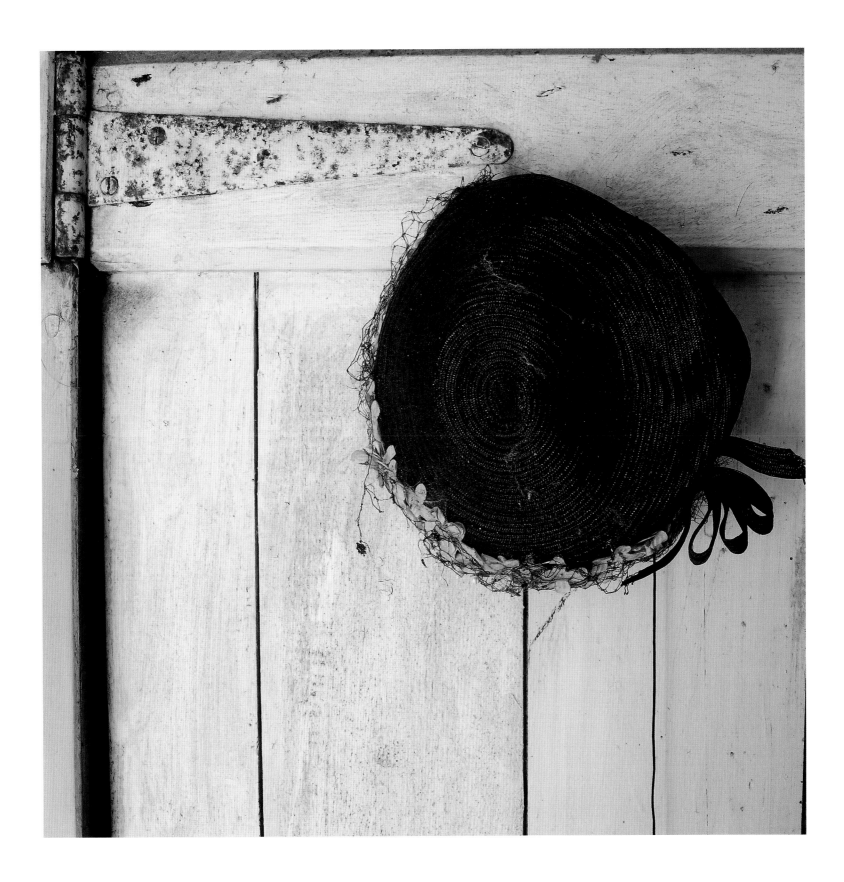

How to decide what's valuable or not? The television was probably taken but the picture of the Sacred Heart and the Christmas lights are left behind.

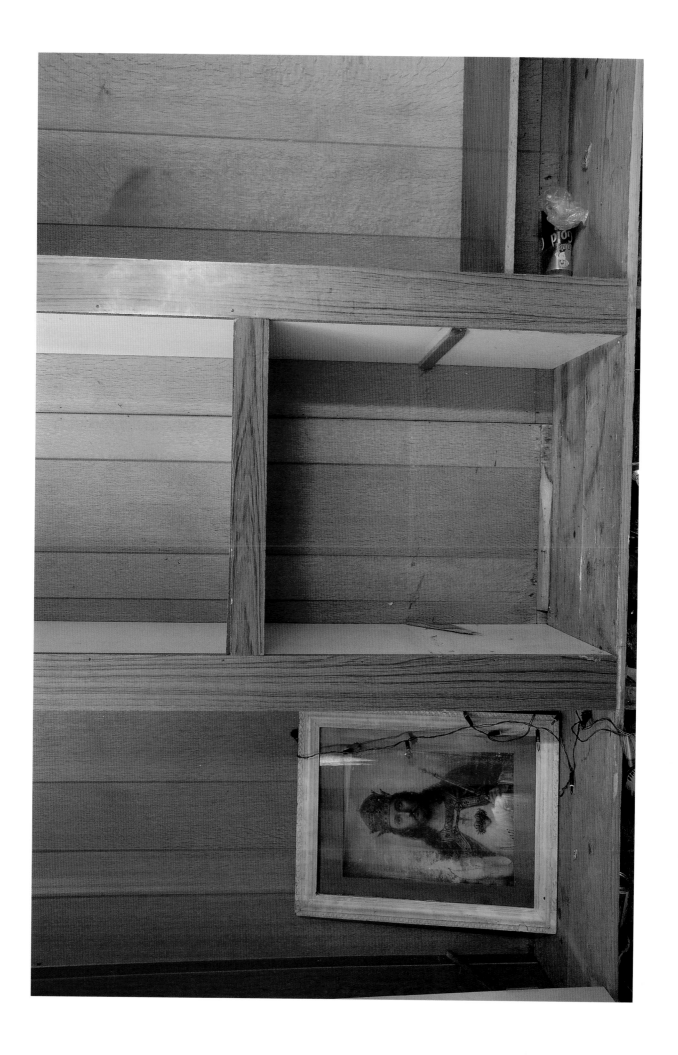

Calendars make it easy to date the last time a house was occupied.

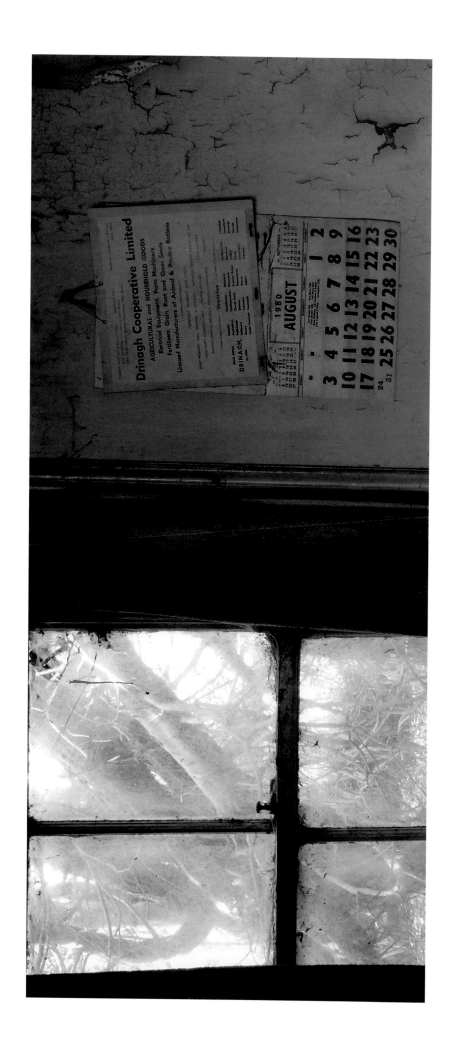

These hat grips were essential to a lady who wanted to make sure her hat stayed put even in Ireland's windy weather. They are rusted beyond use now.

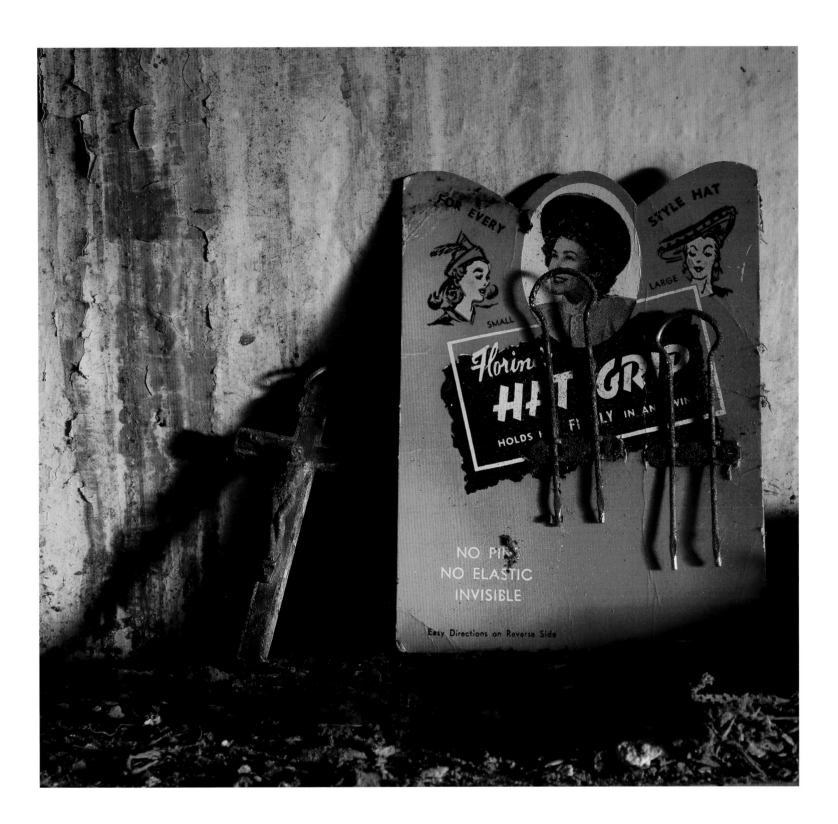

Teapots have always been a large part of any kitchen and here an old pot sits on a windowsill.

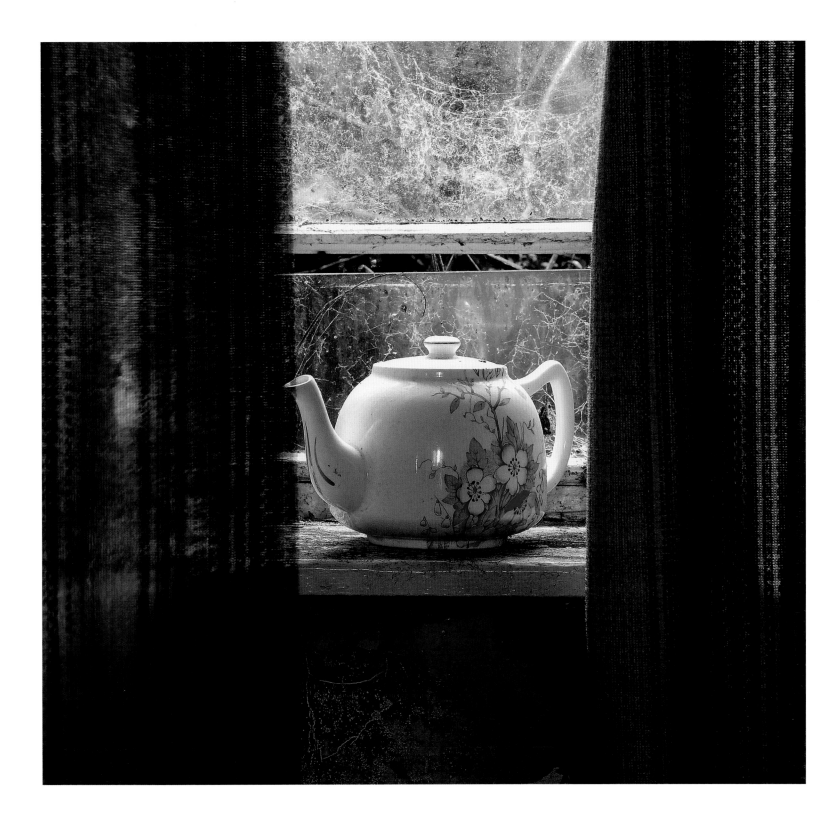

An old teapot with shamrock decoration.
Written on the pot is 'Adrigole'.

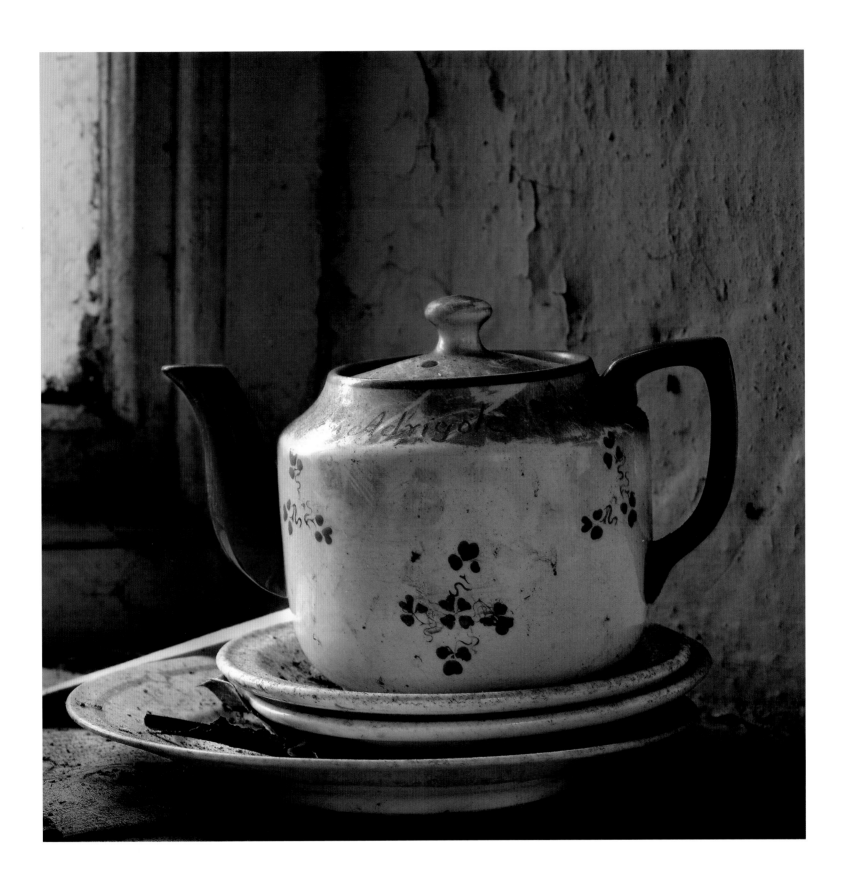

Blue teapot.

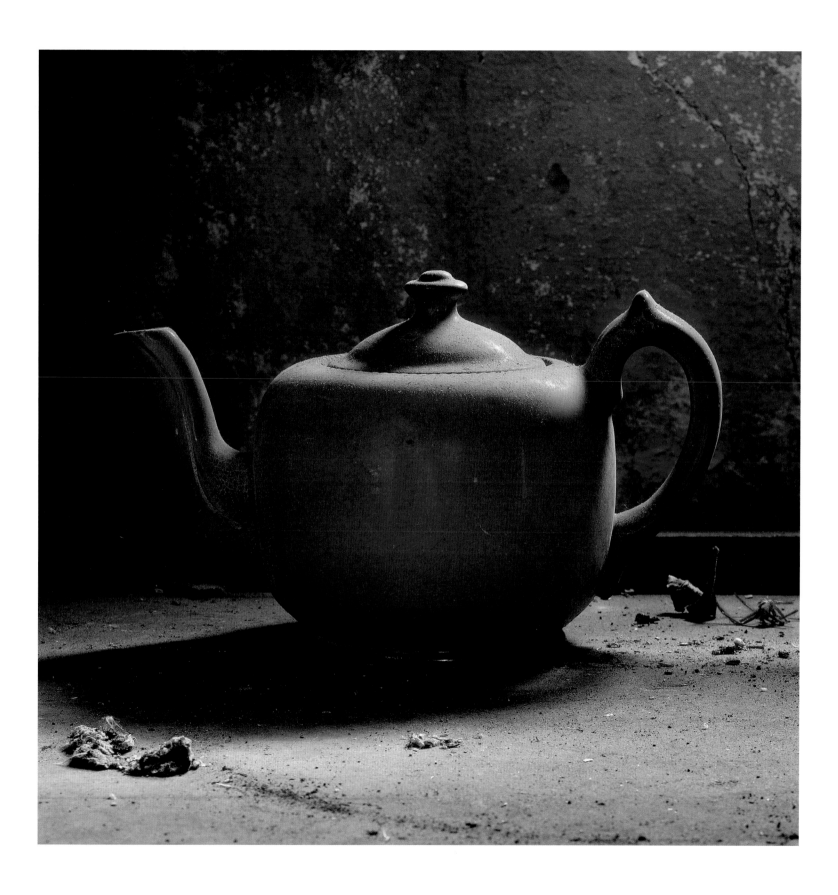

A Paddy bottle containing a clear liquid in front of a picture of Our Lady of Fatima.

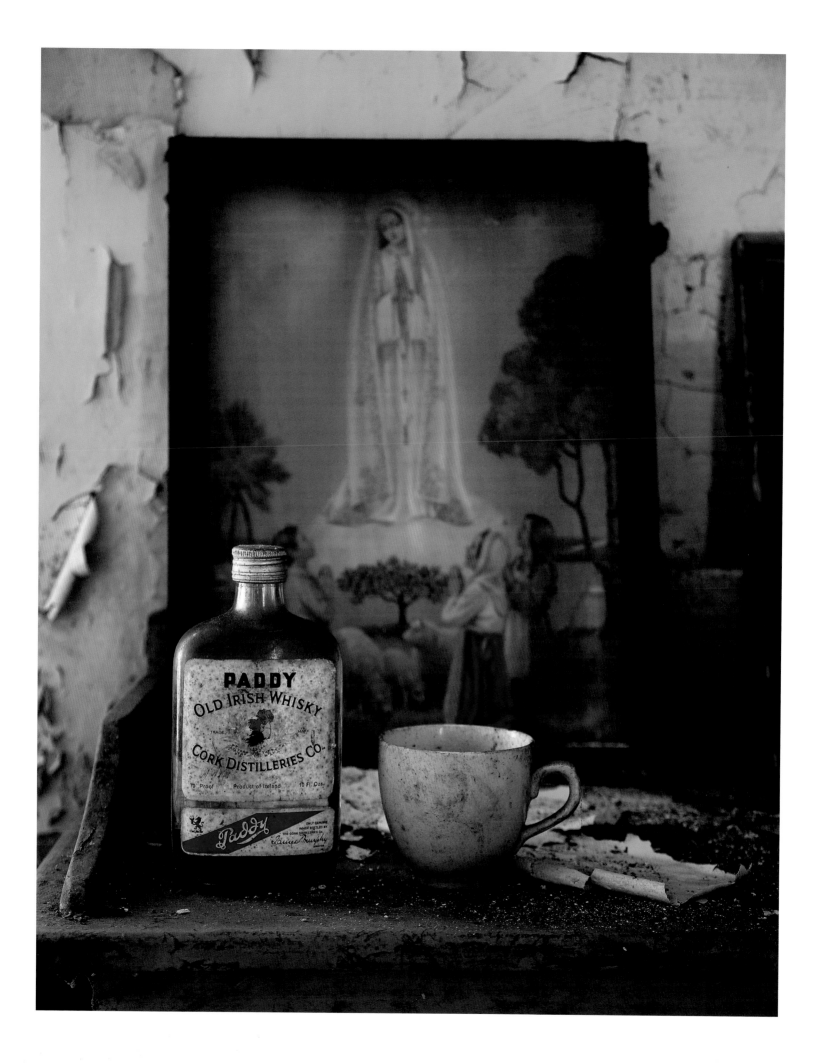

This picture of the signatories of the 1916 Declaration gets pride of place on this mantelpiece.

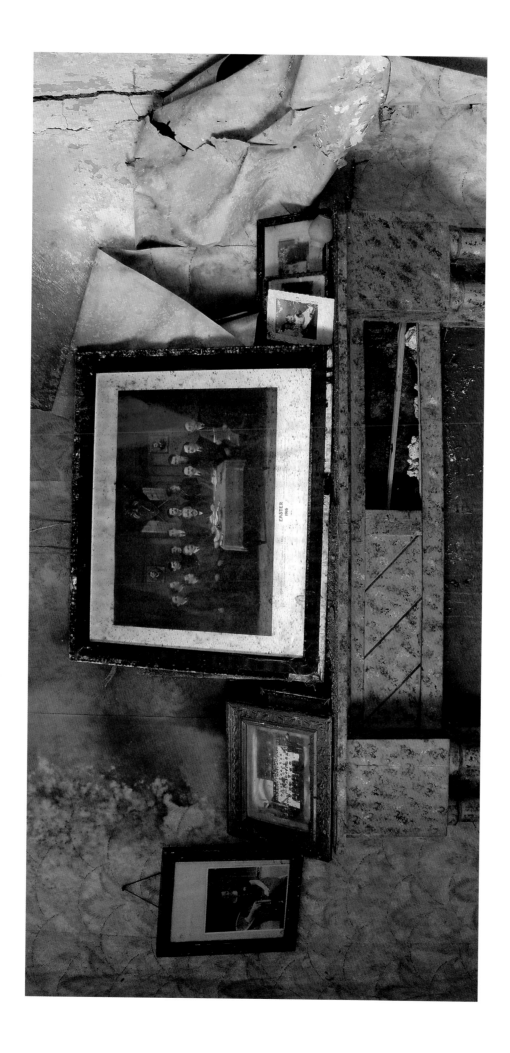

I took two photographs of the same room (*opposite and on the following page*). Even though the photographs were taken only about twelve months apart, in that short space of time the state of the house had deteriorated noticeably.

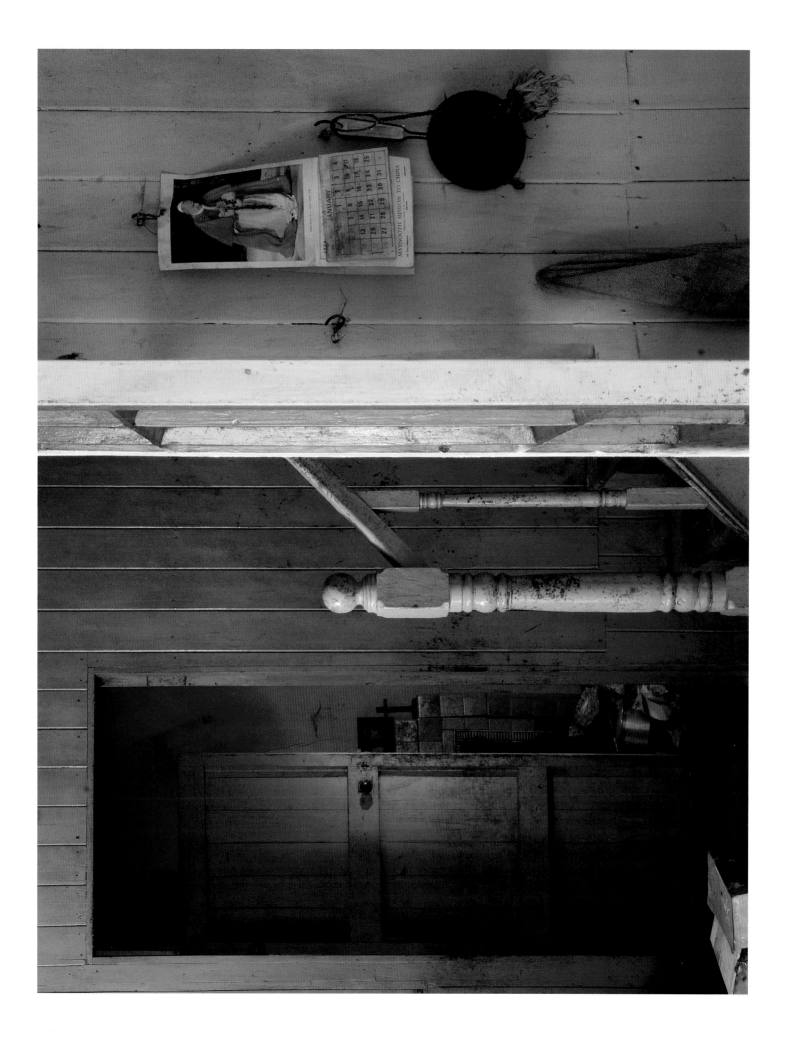

Twelve months later …

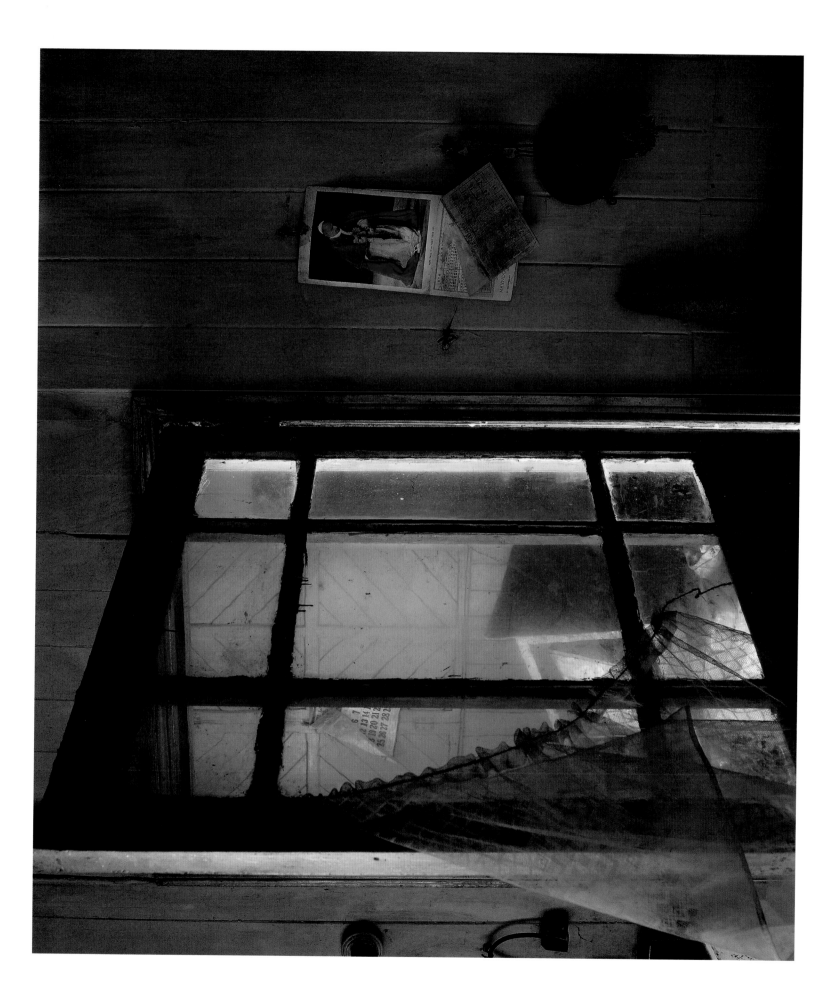

A picture of Pope Pius XII rests on the mantle between
a box of Lyons teabags and a bag of Storm Rat poison.
A pipe rests on top of the tea box.
Pius XII was elected pope on 2 March 1939 and
reined as pontiff during Ireland's holy year of 1950.
In 1948 Radio Éireann began discussing ways in which
the station could celebrate the holy year. After many
meetings between the Secretary of the Department
of Posts and Telegraphs Leon Ó Broin, the Archbishop
of Dublin Dr John Charles McQuaid and the Director
of Radio Éireann Charles Kelly, they eventually agreed
to introduce a simple bell to be played live from the
Pro-Cathedral. Accuracy was important and a landline
was connected to the master clock at the General
Post Office (GPO), which, in turn, was controlled from
the Dunsink Observatory. The live broadcast was
scheduled to start on 1 January 1950 but was delayed
until 23 May because of technical issues. The Angelus
bell at midday and at six o'clock is still in use by
the station today.

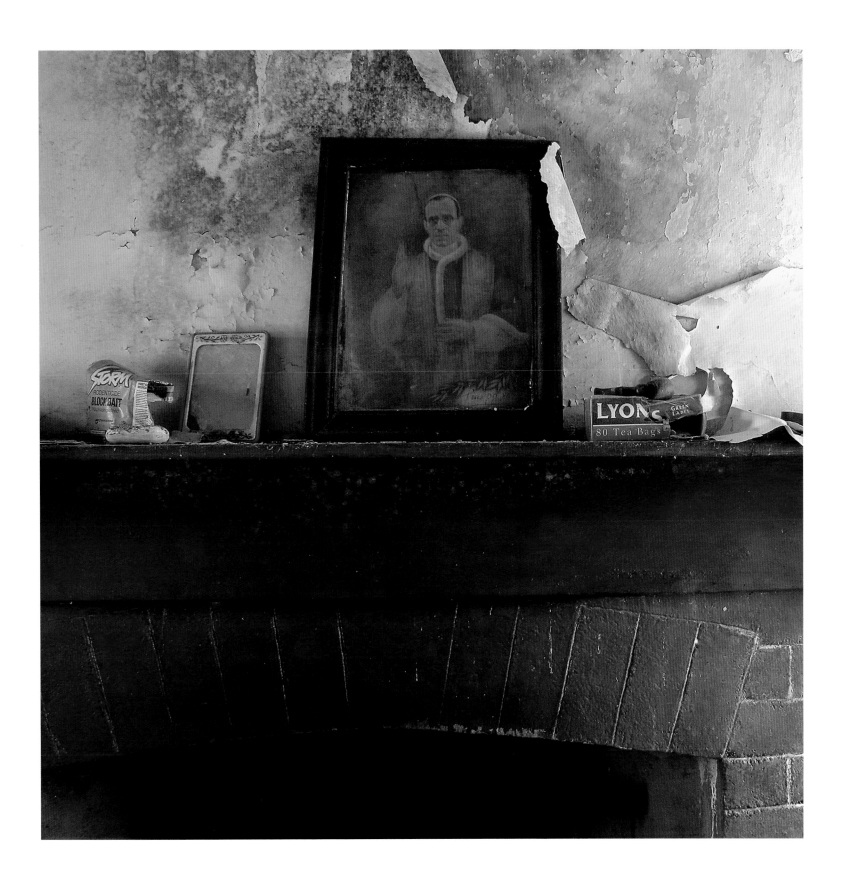

Prior to television coming to our home in 1965 we had an old Philips valve radio that played a central part in our lives. I remember my father would listen to the Light Programme show, Sing Something Simple, which went out on Sunday nights and could be found on the 1500 metres long wave frequency. But the main station that we listened to was Radio Éireann. I recall hearing Leo Maguire on the Walton's Programme with his famous catchphrase 'If you feel like singing, do sing an Irish song' and Frankie Byrne who dispensed romantic advice to the lonely hearts on the Jacob's sponsored Women's Page.

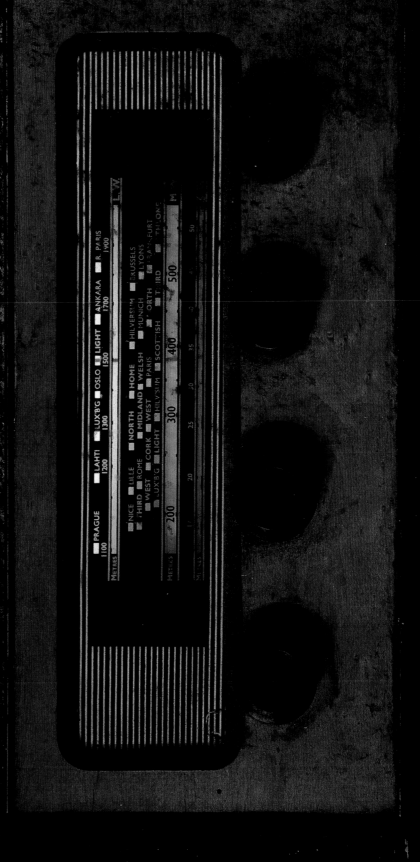

What fascinated me about the old valve radio was its illuminated dial with faraway cities like Prague, Oslo and Lahti in Finland. Our radio at home had three frequencies, long, medium and short wave. When I turned the dial and tuned into foreign stations, I heard different languages spoken for the first time and I realised I was connecting with an outside world that I knew very little about. As I got older I would listen to Radio Luxembourg on 208 medium wave and to the sultry voice of Samantha Dubois on Radio Caroline in the middle of the night. Both these stations would require delicate fine-tuning of the dial to get a better reception.

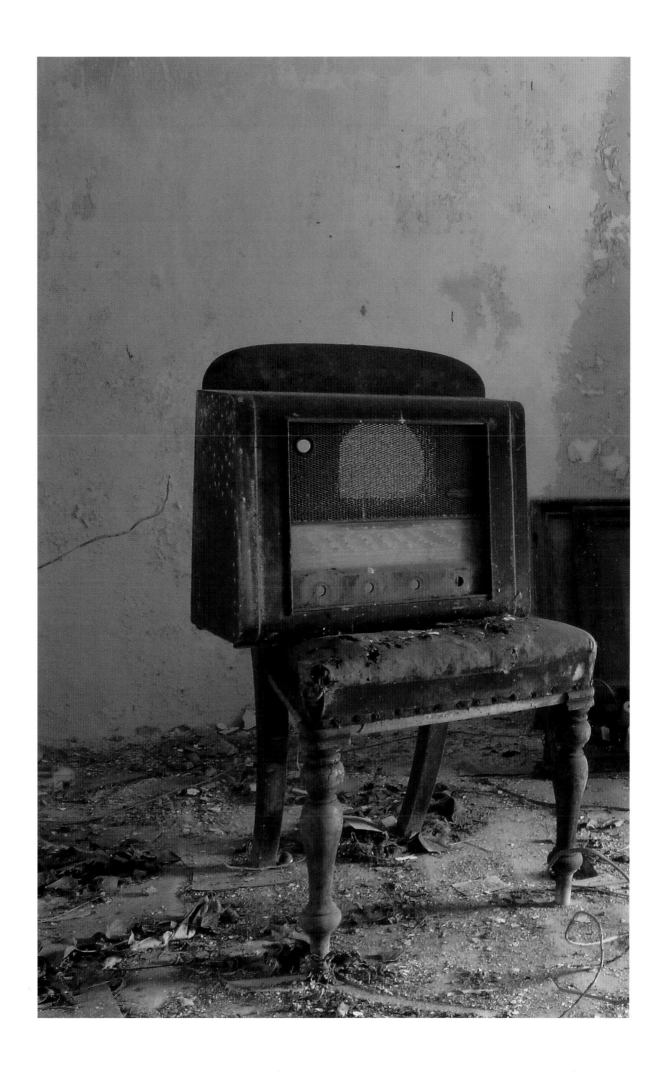

I remember there were always tins of Jacob's Afternoon Tea or USA biscuits in our house at Christmas. From what I can recall the chocolate ones were always the first to be eaten and then in descending order of popularity until mid-January when all that was left were the plain ginger biscuits.

W&R Jacob was an Irish company founded in Waterford in 1881. Shortly afterwards, it moved production to Dublin where it continued until 2009 when the company moved manufacturing abroad.

This old valve radio is on a dresser shelf next to a picture of Pope Paul VI. The radio, model no 285P, was made by the Sentinel Radio Corporation of Evanston, Illinois, USA, in 1946. Also on the shelf is a bible and instructions for feeding newborn calves.

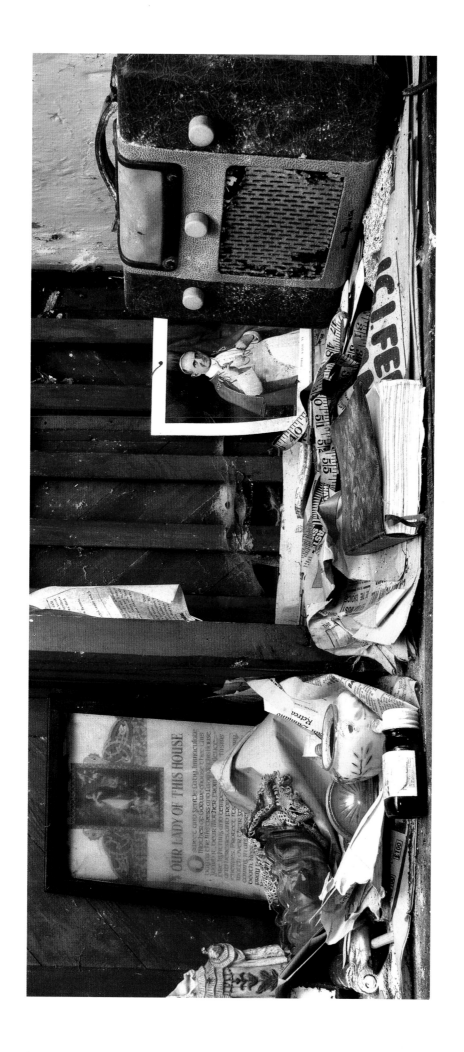

I met Linda Keohane, an artist from Galway, at the opening of my first exhibition in Ireland, which took place in the Ballina Arts Centre, County Mayo. She and her family spend their summer holidays on her aunt's farm in Clooneygorman, County Cork. She told me she had written a story, which was published by *The Irish Times*, about the events of one summer's day in July 1969.

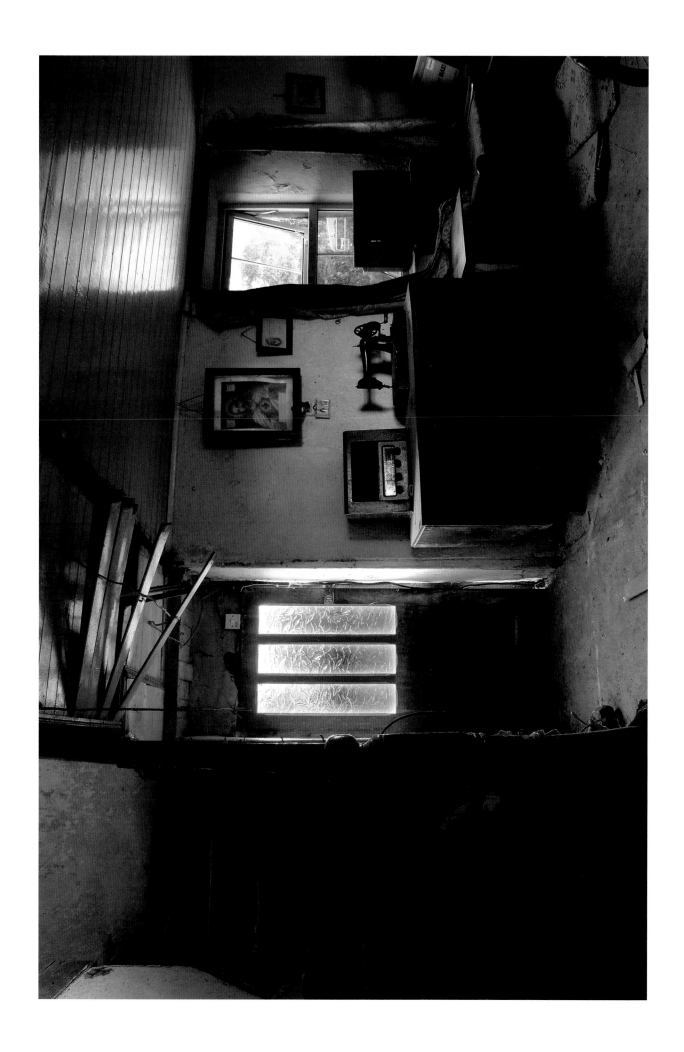

Clooneygorman, 21 July 1969
Linda Keohane

'I never thought I'd live to see it,' said my father, his voice hushed and excited.

'God grant they get home safe, that's the main thing,' my aunt's husband said softly.

We were gathered at the kitchen table in the farmhouse at Clooneygorman in west Cork, my father's sister's home, his own childhood home, where he brought us for a happy fortnight every summer.

As we ate a big hungry tea, my aunt and my mother wondered aloud if it was happening much too late to allow children to see it, but we knew they were only teasing.

I looked at the black box on the shelf and didn't know how I'd live for two whole hours until it started.

All that day, we'd been saving hay. I have, and will always have, as clear as a photograph held in my hand, a memory of sitting on a grassy ditch, watching my father and mother working. My father, the civil servant who'd married late and was fifty-five to my eight years, had his shirt off, his back browned in the sun, and was swiftly and expertly spiking cocks of hay with a pitchfork, hoisting them effortlessly aloft onto a huge tram. He always looked healthier down here.

My mother, child of a small farmer herself, though much younger than Dad, had a lovely rolling rhythm to her work as she gathered the dried wisps of hay. Their whole bodies seemed to move smoothly, fluidly, in harmony, even when she paused for a second to tuck a stray strand of hair behind her ear, or when he rested a moment on the pitchfork to survey what they'd done.

'God bless the work!' called a neighbour from the road behind me, an old man wheeling a bicycle. He stopped and leaned against the ditch, looking into the meadow.

'You're resting, is it?' he said to me, smiling.

'Yes,' I replied. 'I got tired.'

'Ah sure, girleen, when you wouldn't be used to it, from the city,' he said kindly. 'Your father trammed hay for every neighbour around and he not much bigger than you. I never saw a boy with the knack of it like he had, and he has it still.'

'Yes,' I said shyly.

It was a bit embarrassing somehow, this praise of my father. But it was nice too, and brought a glow of pride to my cheeks. At home, I was already beginning to feel ashamed of him sometimes, in front of my friends, with his old-fashioned words and ways, and his grey hair.

'Will ye be staying up tonight, Michael?' asked my father, strolling over.

'We will, we will, Dannie,' he answered.

They all called him 'Dannie' here. It was 'Donal' at home. It was another sign of the changes that came over him in west Cork.

'Ye have the box so, have ye?' asked Dad.

'Arrah no, but Dinny Crowley beside us has it. Isn't it the most awesome thing, Dannie, to think of them up there, and from here it looks the same as it always did?'

I left them, gazing at the faint moon in the summer afternoon sky, and went back to my mother and asked her to show me again the best way to hold the rake, and I tried harder than ever to do it right.

One of the things about my father which used to embarrass me was the way he turned on the TV, and that night he was worse than ever.

First came the plug. He turned it over in his hand as if to check it. He lined it up with the socket. He pushed it in carefully. He put the palm of his hand against its flat back as if to make certain it was fully in. That was just the plug. Then he stood full square in front of the set and seemed to examine it for several seconds, as if the on/off switch might have moved since he'd used it last. He depressed the switch very deliberately, holding his thumb on it, standing stock still in front of the screen, gazing at it as if he'd never seen it before, as if it might never heat up and the black-and-white picture never resolve. 'Move over, Dad!' someone said, always said. Maybe it was me.

And so, late, late into the night, we watched the man on the moon. Apollo 11 landed safely and Neil Armstrong took his small step for a man, his giant leap for mankind, and the children jumped around the kitchen with excitement while our parents went quiet with the wonder of it. And then to bed, and quickly to sleep, for tomorrow there was more hay to save.

It would be many, many years before I would understand what I'd seen that long day. That when I watched my father tramming hay, I was witnessing a skill which had remained unchanged for thousands of years and which would soon be lost from the earth and from the hands. That when I became impatient with him switching on the television, I was looking at a man who, as a child, could never have imagined a day when people could sit at their firesides and watch people walking on the moon.

That as he grew to be a man in west Cork, the moon was what lit his path home through the fields, before there was electricity or streetlights, and only low, flickering oil-lamps in the scattered houses.

That, to the child my father was, the world was so vast that when your three older sisters left for America you might never see them again.

That to his child, only fifty years later, the world was just a small grey ball in a black box on a shelf in the kitchen.

And that one day I would feel utterly, utterly privileged to have been there, at that time, in that place, on this small island, from where I had such a clear and startling view of both the future and the past.

Here a picture seems to be the only thing holding up the sagging wallpaper. In the foreground is a red transistor radio and a Singer sewing machine, a similar model to the one my mother used at home. The sewing machine was operated by a foot pedal and more delicate work was achieved by turning the wheel by hand.

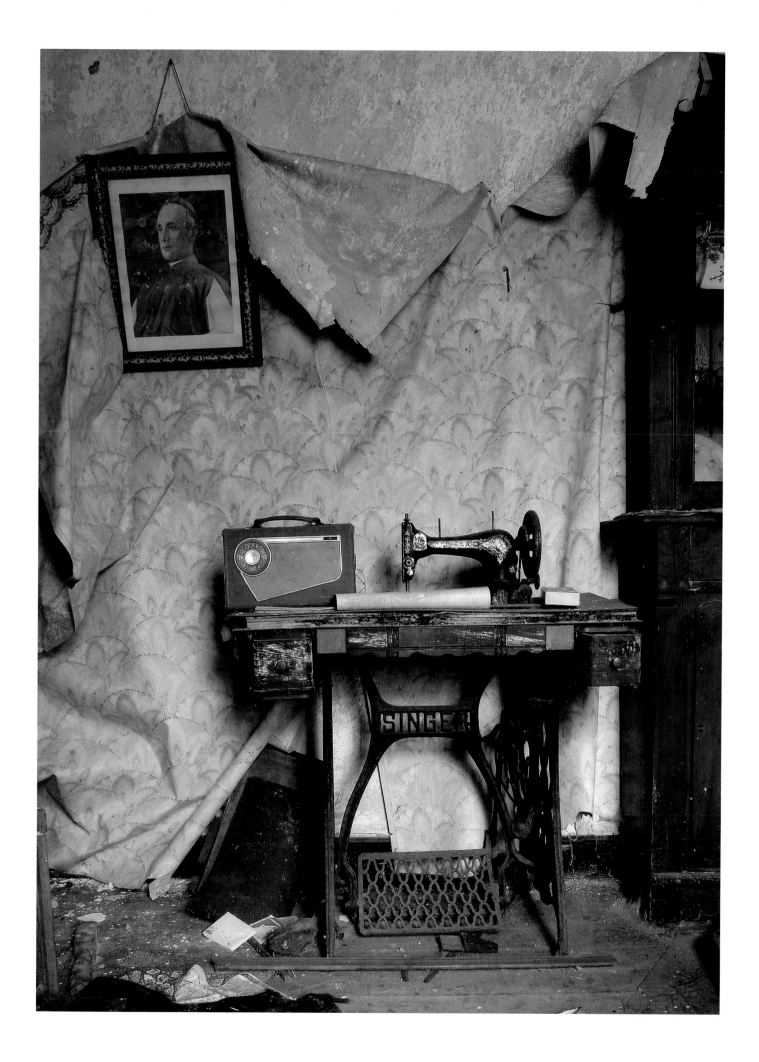

Another radio on another dresser in another kitchen.

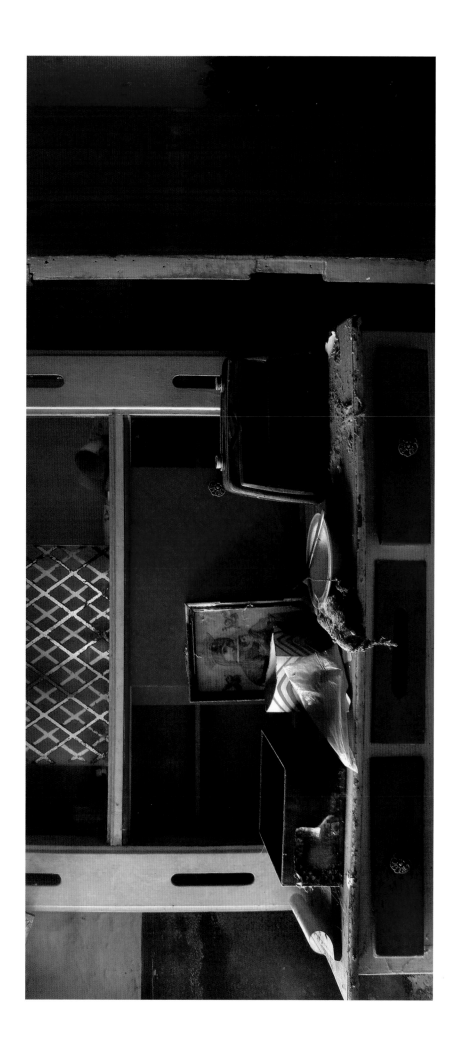

Almost every home had a statue of the Child of Prague. Some people kept a brown-paper-wrapped halfpenny underneath the statue in the belief that the Holy Child would see that 'the house was never without money'. The practice of putting the statue out in the garden before a wedding was widespread in some areas of the country as brides, grooms and their families hoped it would bring fine weather. I can still remember my mother placing one in the garden the day before my sister's wedding. Most of the statues I encountered had the head missing as a result of inevitable accidents over time.

The Infant Jesus of Prague statue originally came from Cordoba in Spain. Its earliest history can be traced back to 1556 when the wax statue was given as a wedding gift to the Duchess Maria Manrique de Lara by her mother.

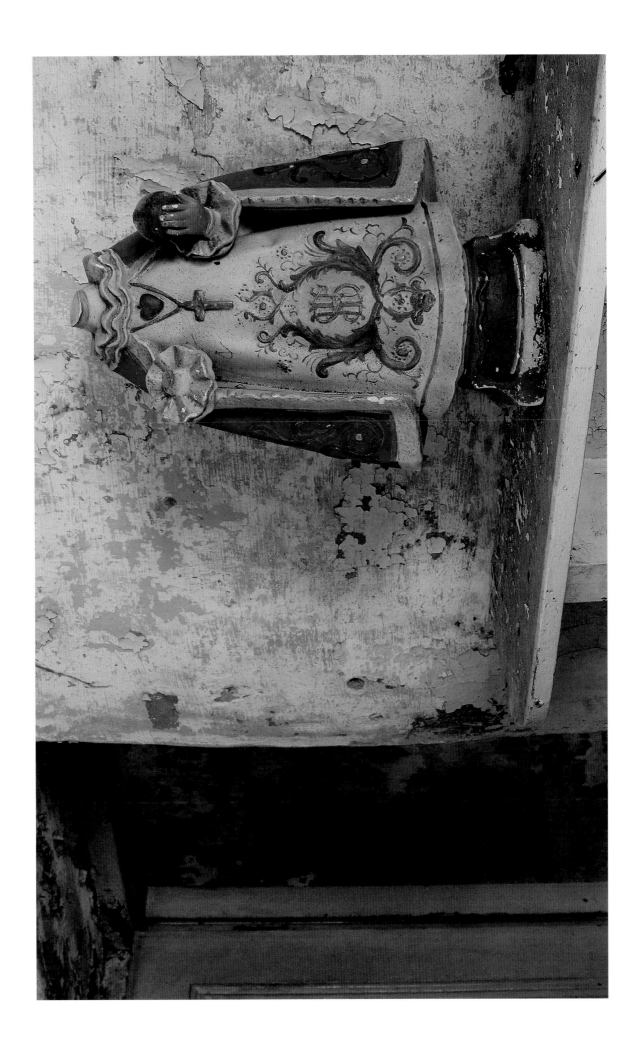

This was the only time I came across a statue of the Infant of Prague with its head on. The slightly askew picture is of the Annunciation where the Archangel Gabriel tells the Virgin Mary that she would become the mother of Jesus.

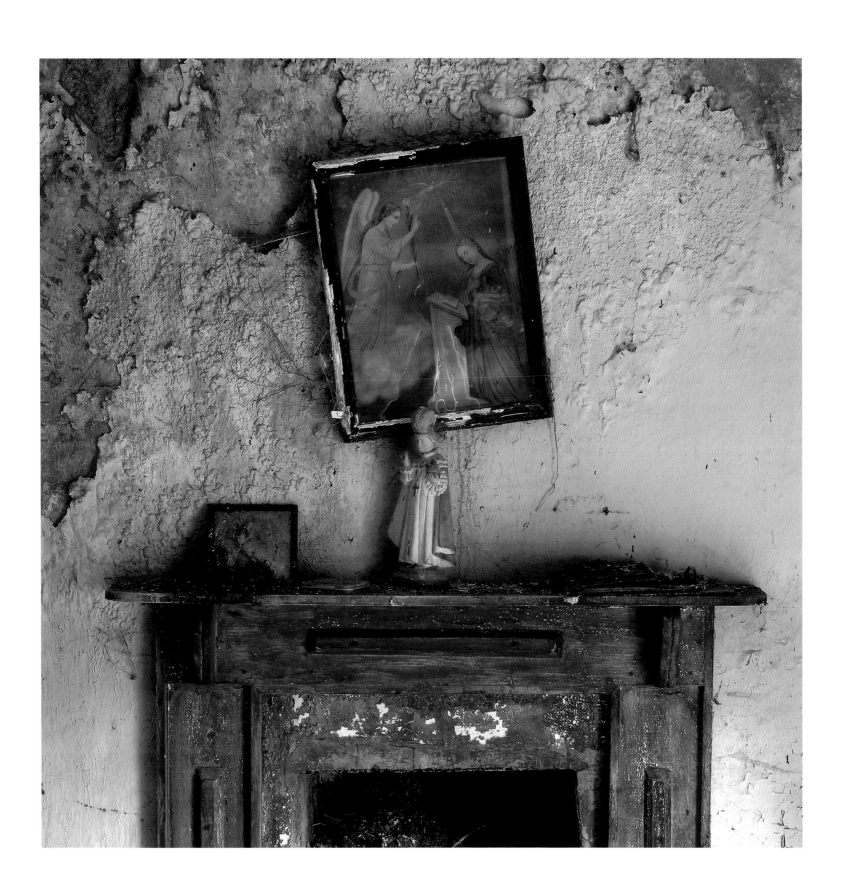

A statue of the Infant of Prague with its head missing stands near a pair of clocks. Next to the statue is a statement from the Internal Revenue Service dated 1967 and a timetable for liner sailings for the Holland America Line in New York.

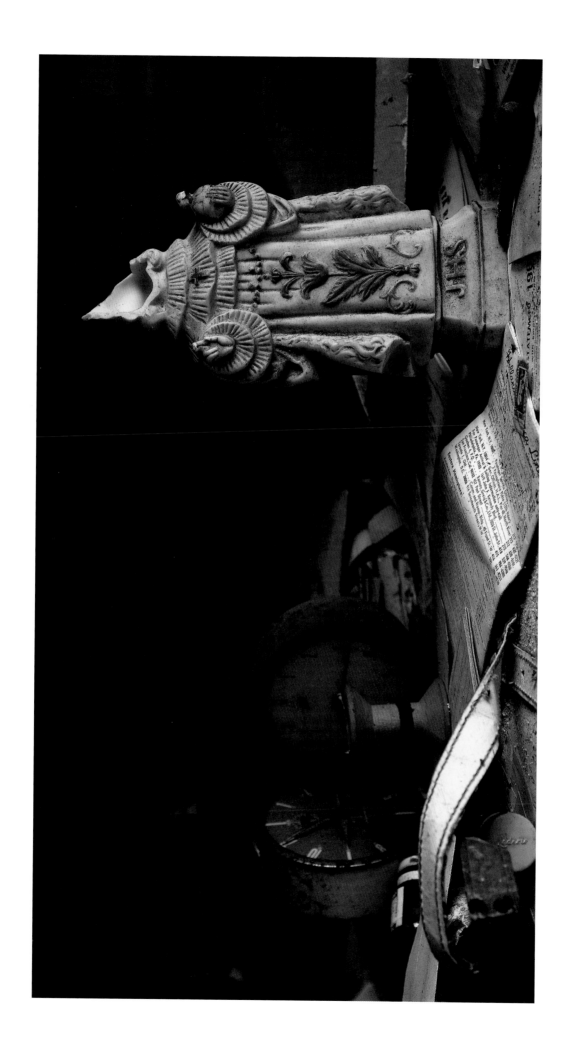

The kitchen is the heart of the home and the stove is the heart of the kitchen.

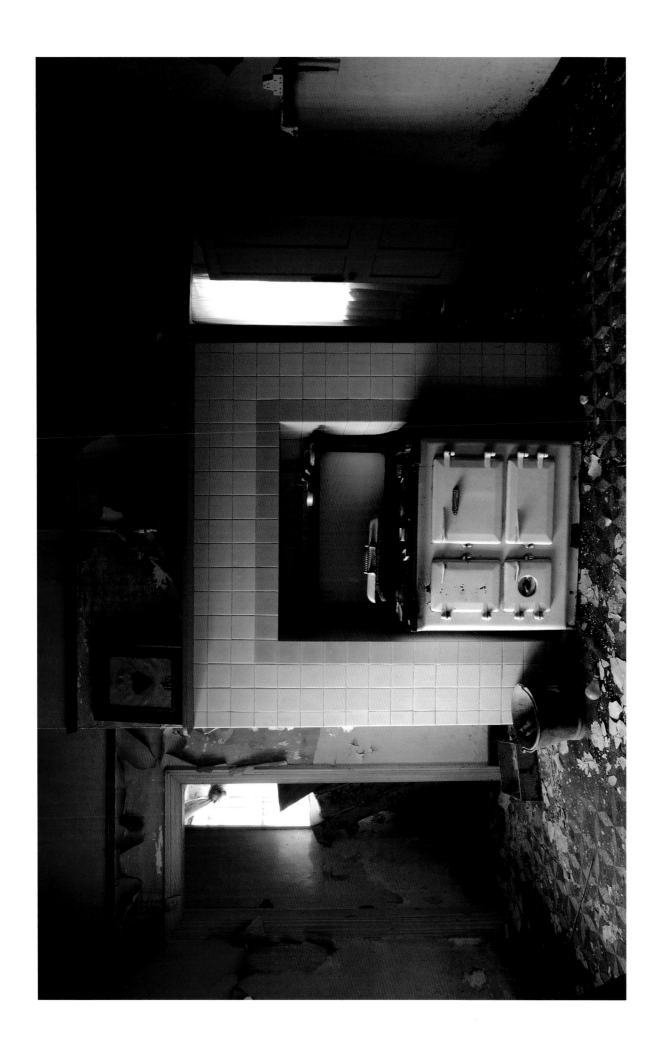

This stove had pride of place in the kitchen with the ubiquitous chair in the corner for special visitors or for simply taking a moment.

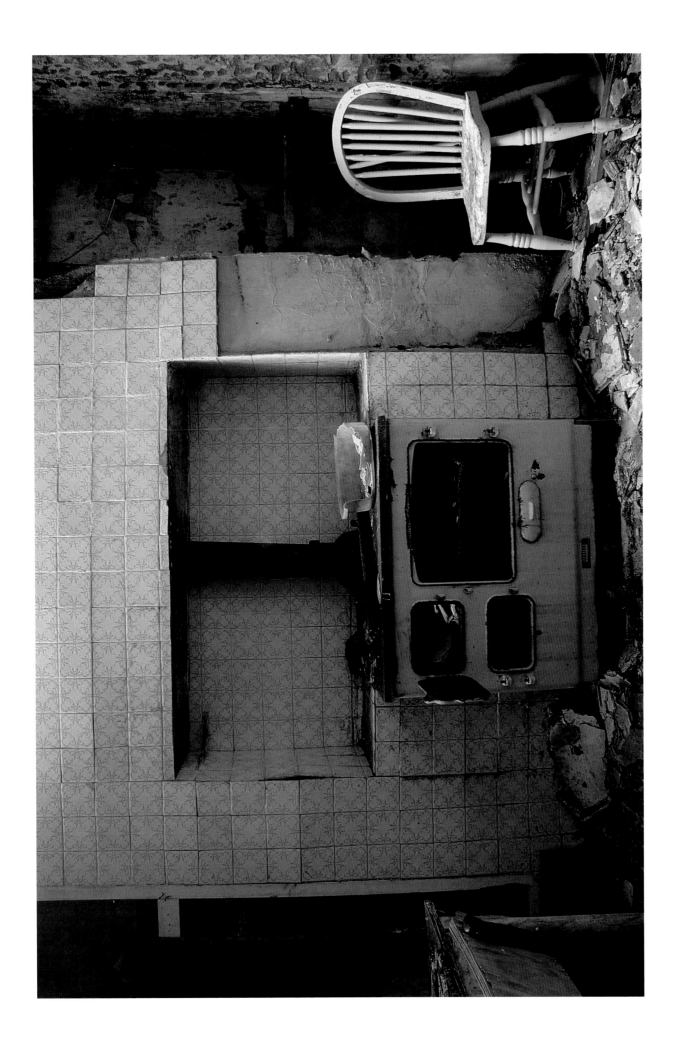

A glass Guinness bottle sits alongside a small statue of Our Lady and a framed membership of the Franciscan Mission Association in Union City, New Jersey, USA, which was granted to Margaret McNamara at the request of the Haggerty and O'Brien families.

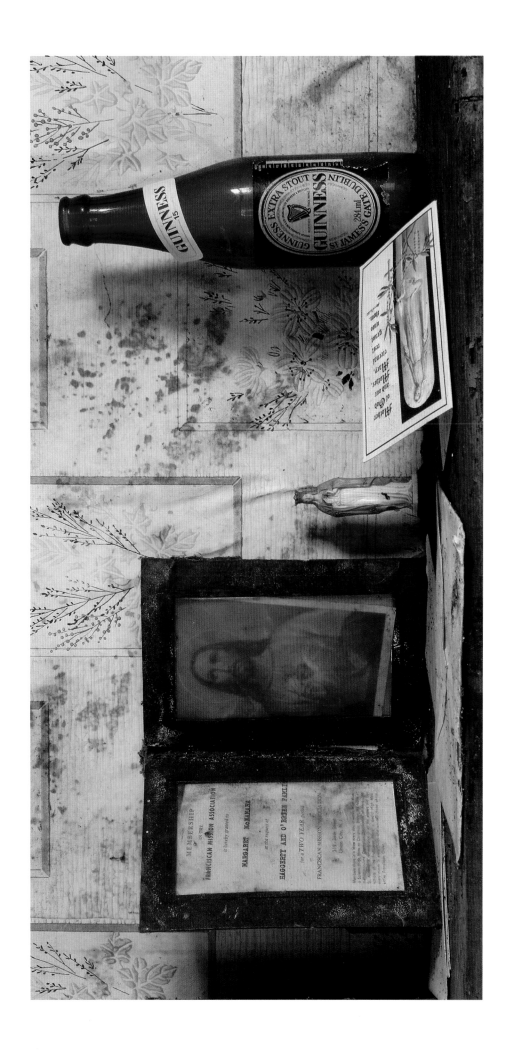

This house was being used as a shelter for cattle. I had not expected to find anything to photograph here but I discovered this old battered piano in one of the two downstairs rooms.

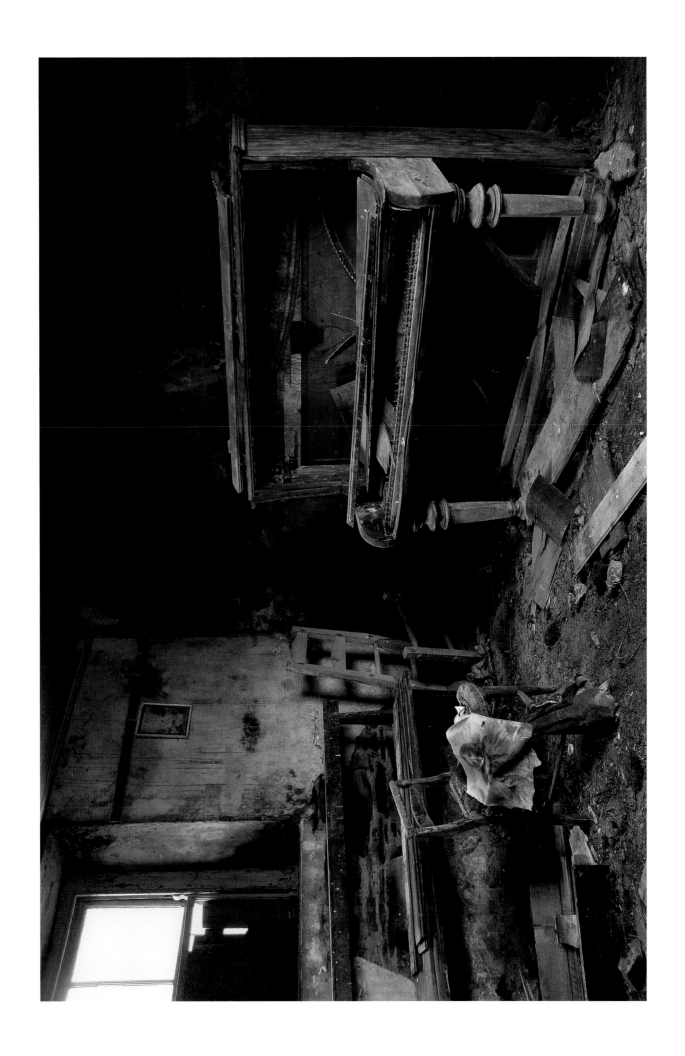

The empty interior of Dursey Island School a number of years after its closure in 1975.

In 1961 the population of Dursey Island, County Cork, was sixty-five. Today this has fallen to just six inhabitants.

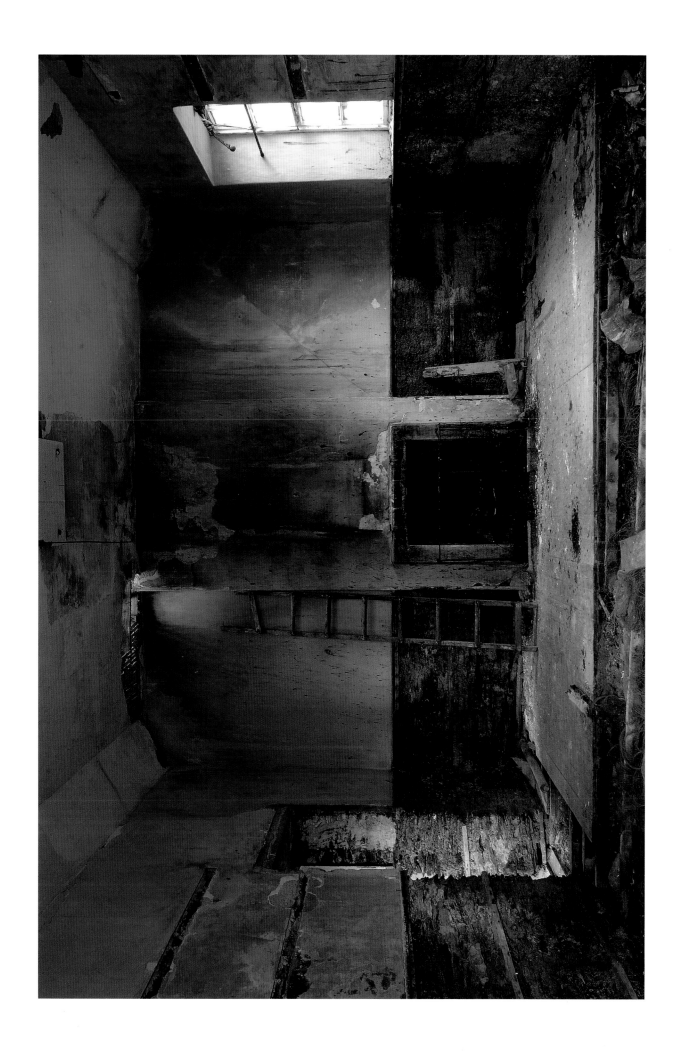

I went to the Model National School in Cork city centre. The school building, which is now the District Court, is on Anglesea Street and faces the City Hall. Sometimes after school my friends and I would go down to Kennedy Park to play football. Kennedy Park or 'The Boggy' as it was commonly known is situated near Monahan Road. On one occasion somebody suggested that we go down to the docks to see the Innisfallen go out. The Innisfallen was owned by the City of Cork Steam Packet Co. and sailed between Cork and Fishguard every Monday, Wednesday and Friday, and was held with great affection in the hearts of Cork people. The Innisfallen of the 1950s was the third ship to bear the name and was launched in 1948.

Thousands took the ship to England, where they found work in the factories and building sites. Some found work at the Ford Motor Plant in Dagenham, London, a place that became known as 'Little Cork'. When they returned for holidays they were known as 'Dagenham Yanks' because of their trendy clothes and English accents. The Irish who worked on the building sites in England led a somewhat nomadic lifestyle, going from job to job wherever there was a need for their labour.

For me there was a sense of great excitement about the boat. I had heard it talked about at home from time to time when some relative would arrive from England. My first sight of the Innisfallen was of its black and white structure with one funnel and a lot of people milling around on the quayside. My preconception of ships leaving had come from films and I was expecting a band playing and tickertape but this was different. Instead, what I witnessed was an eerie quietness, something I did not expect. I can still see cattle being loaded up a gangway and men in overcoats holding suitcases that were held together with belts. When it left, the boat went out to the center of the channel before reversing down the river to turn. As it made its way well-wishers walked alongside down the quayside waving white hankies.

GENERAL INFORMATION

SAILING TICKETS will be required on the following Sailings only :

Ex Fishguard—Tuesday, July 31st and August 7th.
Thursday, July 26th, August 2nd and 9th.
Saturday, July 28th, August 4th and 11th.

Ex Cork— Monday, August 6th, 13th and 20th.
Wednesday, August 8th.
Friday, August 3rd, 10th, 17th, 24th, 31st and September 7th.

BUS SERVICE. A bus service operates from the Innisfallen side at Cork to the Terminus for Country Bus Services. Tickets from Cork to destinations in the South of Ireland may be obtained from the Purser.

PASSPORT OR TRAVEL PERMIT. All passengers travelling to and from Ireland (except members of H.M. Forces and children under 16 years of age) must be in possession of a valid Passport or Travel Permit Card.

NOTICE OF CANCELLATION of cabin or berth reservations should reach the Company not later than 10.30 a.m. on date of sailing. Unless such notice is received, refund of fees cannot be made.

MEALS may be obtained on board and a Restaurant Car is provided on connecting trains in some cases for portion of journey only.

BICYCLES must be handed over for shipment at Cork not later than 3.30 p.m. on day of sailing.

DOGS are not permitted in Passenger accommodation. They must be placed in kennels provided. Charge for use of kennels 5/- for dog accompanied, 10/- unaccompanied.

LUGGAGE. Passengers' luggage up to 150 lbs. First Class and 100 lbs. Third Class carried free.

PASSENGERS AND THEIR LUGGAGE ARE CARRIED ON THE CONDITIONS SPECIFIED IN THE COMPANY'S SAILING BILLS WHICH MAY BE INSPECTED AT ANY OF THE COMPANY'S OFFICES.

ALL SAILINGS ARE SUBJECT TO ALTERATION OR CANCELLATION WITHOUT NOTICE.

For Information, Travel Tickets, Berth Reservations, apply :
CITY OF CORK STEAM PACKET CO. (1936) LTD.
Passenger Booking Office, 112 St. Patrick Street, Cork.
Telegrams : " Packet, Cork." *Telephone :* 23231

LONDON OFFICE :

BRITISH & IRISH TRAVEL AGENCY,
227 Regent Street, W.1.

Telegrams : " Comfyships, Wesdo." *Telephone :* Mayfair 9947

or to Agents —COAST LINES LTD.

FISHGUARD, Goodwick S.O. South Wales	*Tel.* 2236
BIRMINGHAM, 4. 108 Dale End	*Central* 3612-3
BRISTOL, 1. The Grove	21142
CARDIFF, Seaway House, 55 Bute Street	3710
LIVERPOOL, 3, Royal Liver Building	*Central* 5464
PLYMOUTH, Dominion Hse., Drake's Circus	2589
SOUTHAMPTON, Seaway Hse., Town Quay	2151/2152
SWANSEA, Exchange Buildings	2016

or Railway Stations and Principal Tourist Agencies.

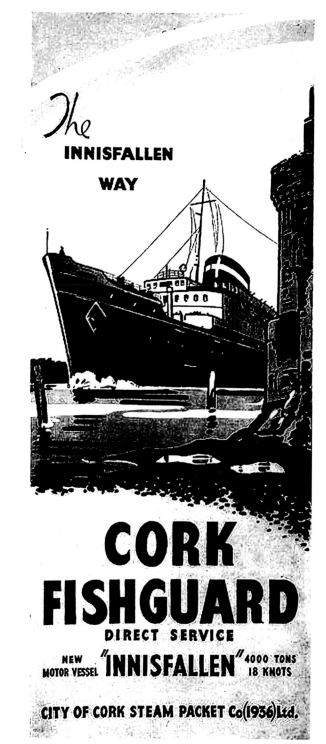

The
INNISFALLEN
WAY

CORK FISHGUARD
DIRECT SERVICE
NEW MOTOR VESSEL "INNISFALLEN" 4000 TONS 18 KNOTS

CITY OF CORK STEAM PACKET Co (1936) Ltd.

The orange wallpaper in this photograph is the
exact same pattern as the one on the walls of
our holiday home in Crosshaven, County Cork.
On seeing it I was transported back to when I was
about five or six years old. To this day I can still
remember waking up to a terrible noise: it was
the first time I heard the foghorn at the nearby
lighthouse at Roches Point. As I lay in bed listening
to this new sound my eyes followed the pattern
around the designs of the wallpaper.
Thousands of emigrants passed Roches Point
Lighthouse as they headed to England or America.
Some never returned. I can still remember great
liners like the United States and the France
anchored outside the mouth of the harbour and
watching the tender Cill Airne bringing passengers
from Cobh as they left to begin a new life elsewhere.

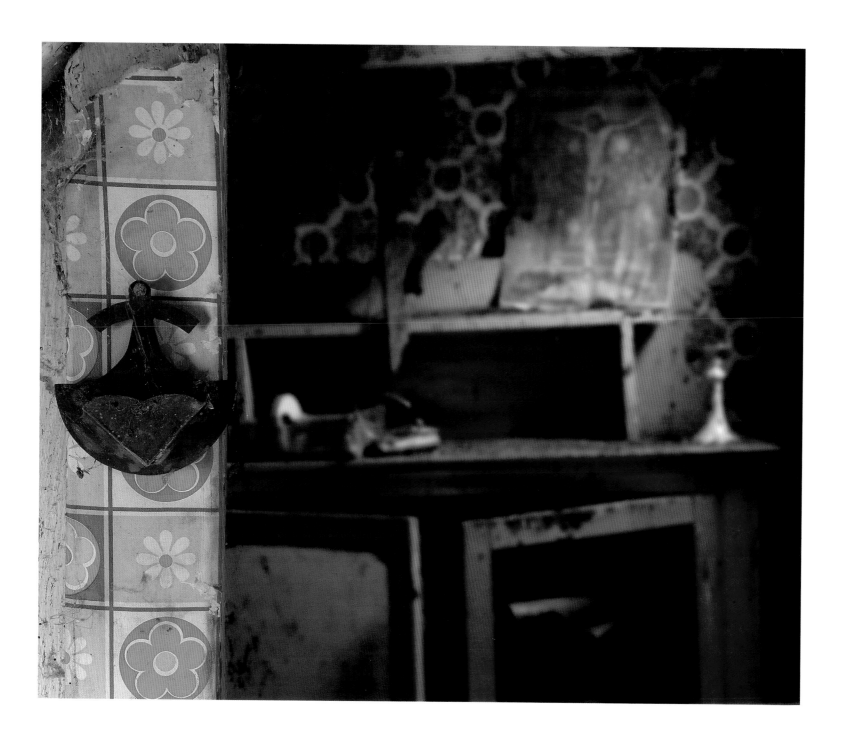

This is the kitchen of a house in west Cork that, over the years, has become cocooned by surrounding trees that make it almost impossible to see from the road. It is a time capsule of sorts.

Inside, a calendar on the wall, dated 1977, has a picture of Pope Paul VI. In the centre of the kitchen is a solid fuel stove and scattered around the floor are kettles, newspapers and a blue tin (decorated with shamrocks) of Jacob's Irish party biscuits, which now contains letters and bills. On top of the tin sits a snow globe and to the right of the stove is a picture of Our Lady of Perpetual Succour.

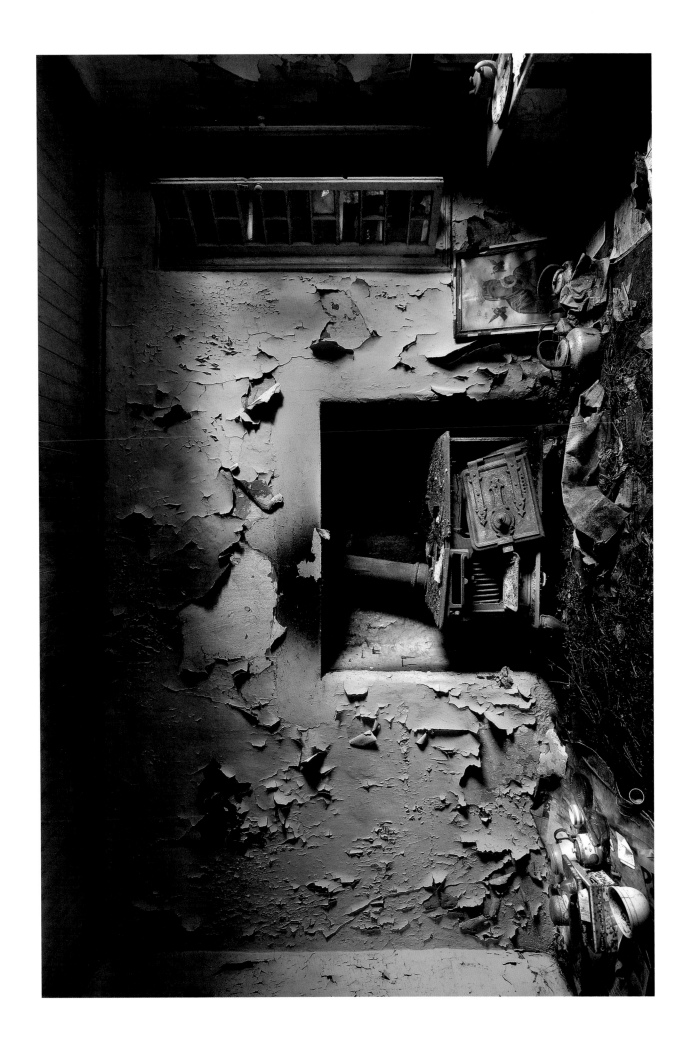

The clock on this window sill is stopped at twenty-one minutes past twelve and lying next to it is an Irish Sweepstakes ticket that could have changed someone's life forever.

The Irish Hospital Sweepstakes was established in 1930 to help raise funding for investment in hospitals and medical services. Because of the low population of the country, a substantial amount of the funds were raised among the emigrant Irish communities in England and America. The results of several horse races, including the Cambridgeshire Handicap, Derby Stakes and Grand National, decided the winner.

Sales of sweepstakes reached a peak of £18 million in 1961 but in later years experienced falling sales because of competition from other styles of lotteries. The final sweepstakes was held in January 1986 and the company went into liquidation in March 1987 after it bid unsuccessfully for a licence for the Irish National Lottery, which was won by An Post later that year.

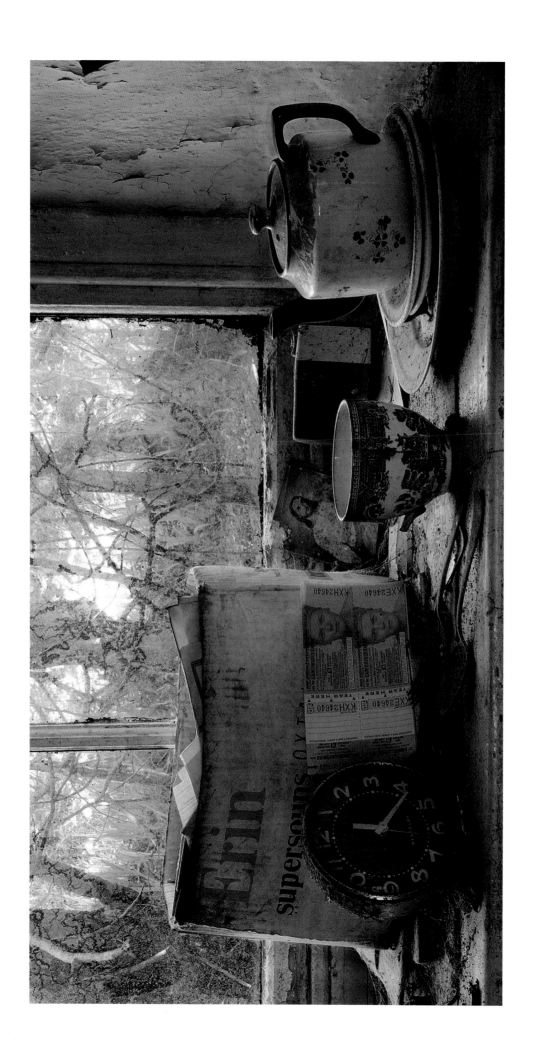

This home had connections with America; on the ground was *The Art of Irish Cooking* by Monica Sheridan and a book on the American Constitution. Upstairs on the landing was a Star Spangled Banner with forty-eight stars – this dates the flag to somewhere between 1912 and 1959. The flag hangs at an angle of forty-five degrees and reminds me of Joe Rosenthal's Pulitzer-Prize-winning photograph of the raising of the flag at Iwo Jima. Next to the flag is a green dress. This house is very dark inside and even though I had been here a number of times I did not see the flag until one morning when a streak of light caught the red colour. The exposure time was six minutes and I had to be careful not to move around too much because any movement on the floorboards would cause camera shake.

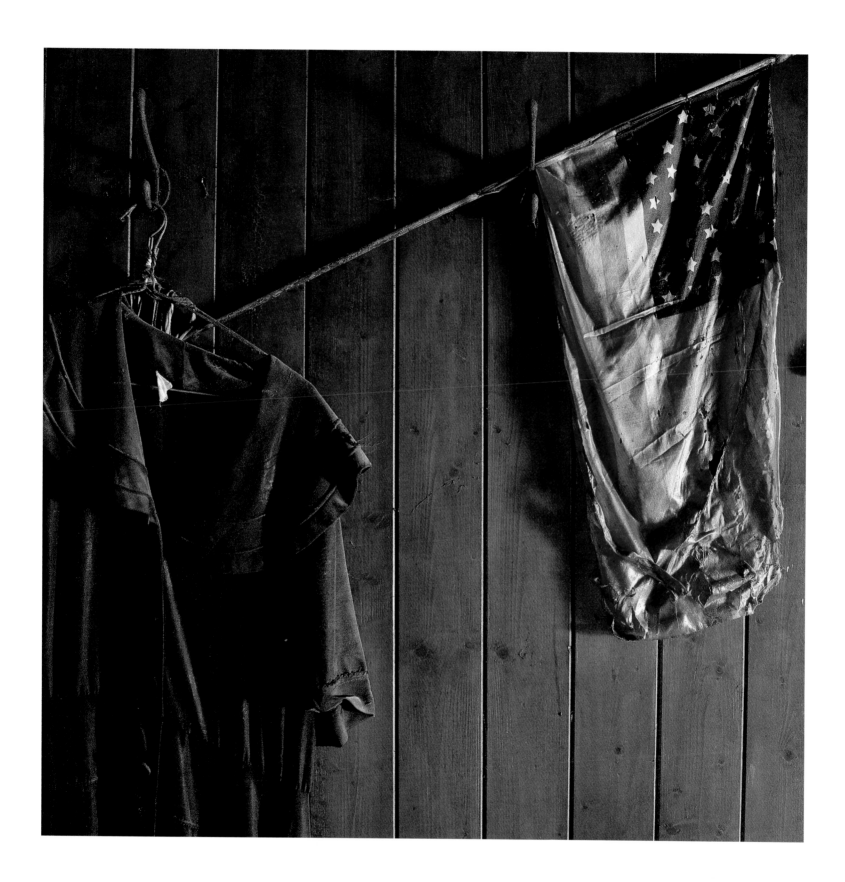

The dream of many exiles was to return to their homeland one day but very few were so lucky. Mary Sullivan travelled to New York on the White Star Liner RMS Cedric that sailed from Liverpool on 11 October 1930. She boarded the liner at Queenstown (now Cobh), County Cork, sailing third class. She returned nineteen years later.

TOURIST THIRD CABIN

PASSENGER LIST

R.M.S. "CEDRIC"

From LIVERPOOL to BOSTON and NEW YORK
(Via QUEENSTOWN and GALWAY)
SATURDAY, 11th OCTOBER, 1930

COMMANDER :

R. G. SMITH

CHIEF ENGINEER - T. GRIFFITHS

Chief Officer - - A. MOFFAT	Senr. Second Engineer S. L. PARKER	
First Officer - - G. STEELE	Senr. Third Engineer - G. DALGLEISH	
Second Officer H. HOLEHOUSE	Senr. Fourth Engineer	
	R. N. BARKER	

Surgeon - C. H. WILSON, L.S.M., R.C.S., R.C.P. (Ire.)

Purser - - W. J. O'HAGAN	Asst. Purser . - - R. R. ELLIS
Chief Steward -D. C. WILKINS	Chief Tourist Steward - P. J. BURKE

From LIVERPOOL

Atkinson, Mr. J. T.	Bell, Mr. C.
Atkinson, Mrs.	Bell, Mrs.
	*Bell, Mrs.
	*Bell, Miss S.
Barnes, Mr. R.	*Bell, Mr. R.
Barrett, Mrs. M.	*Boocock, Mr. G.
*Beake, Miss D.	*Burrell, Miss I. G.

* Disembarking BOSTON

Her trunk tells a story of emigration and
return. The labels state: ' Mary Sullivan,
USS America, August 16 49, Pier 61,
New York to Cobh, Cabin Class Hold.'
The USS America had three classes of
passenger – First, Cabin and Tourist.
On the menu for Cabin class passengers
Mary could choose from caviar or wild
Irish smoked salmon.

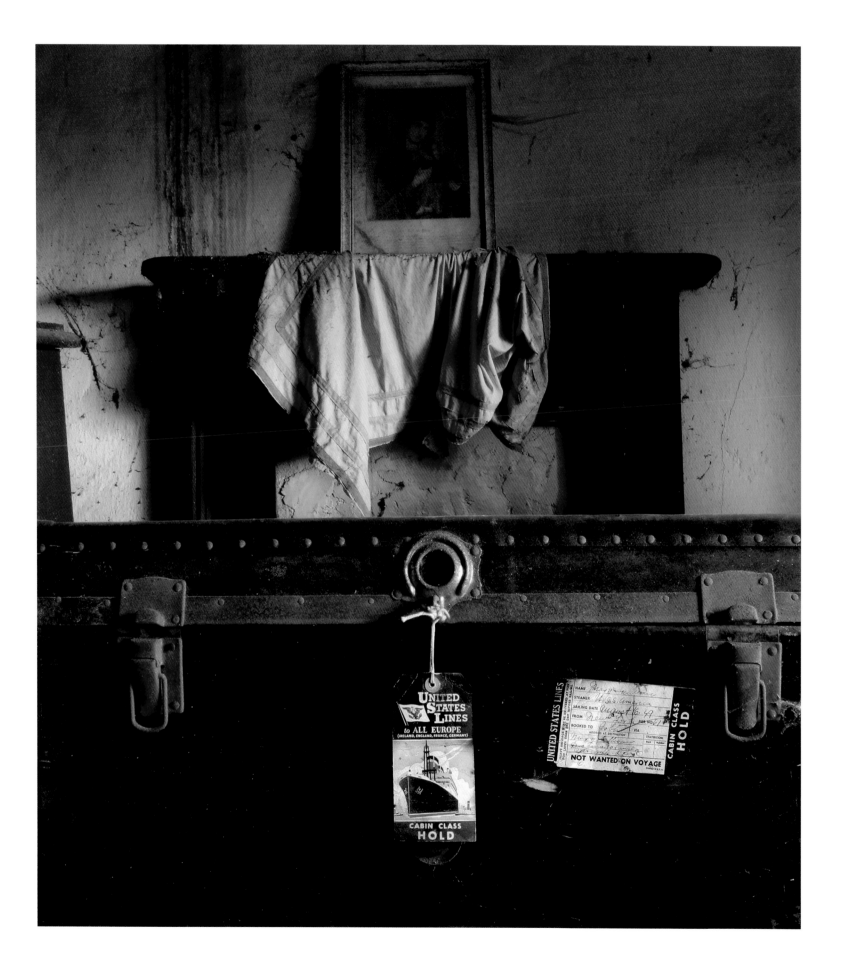

Did Mary Sullivan just abandon this trunk upon her return? Why did she not remove even the tags? Were they a link to her life in America?

The trunk still contained ladies' nylon stockings in their original box with the words 'Nylons by DuPont' embossed at the top of each stocking. Also included among Mary's possessions was a box containing a bottle of Yardley Bath Freshener and a passbook from the National Hibernian Bank in the Bronx, New York, which showed that she had savings of $9,000.

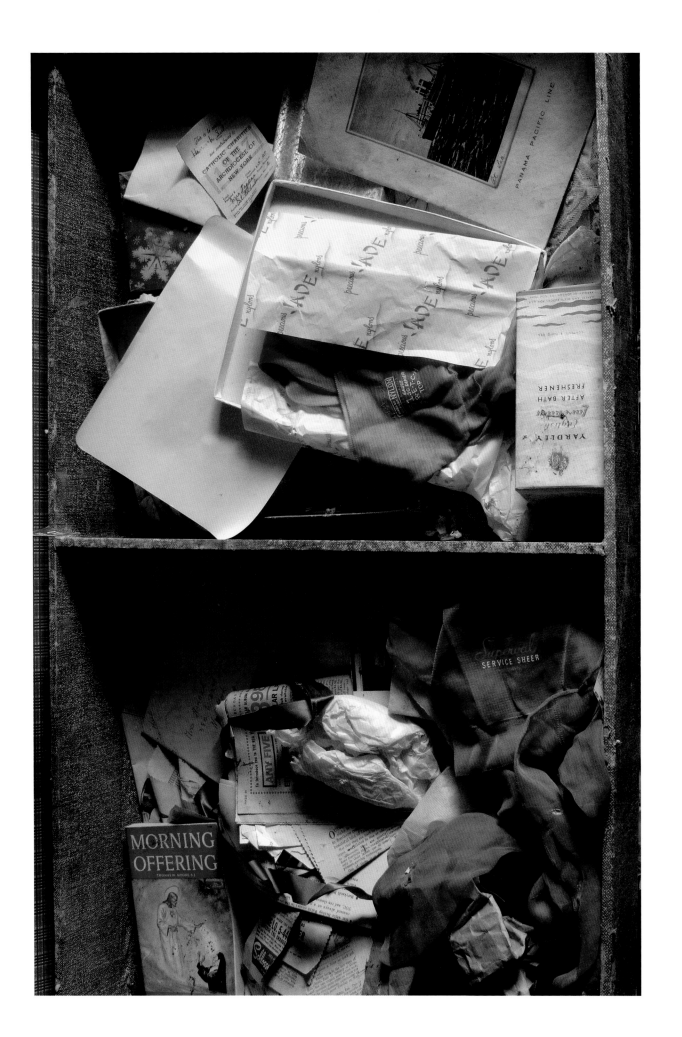

Built in 1938, the USS America was designed by the noted naval architect William Francis Gibbs. USS America entered service as the flagship of the United States Lines on 22 August 1940. She could carry 543 in cabin class, 418 in tourist class, 241 in third class and had a crew of 643. In June 1941 she was acquired by the US Navy and used as a troop transport ship.

After the war she returned to the United States Lines to sail the North Atlantic route of New York–Le Havre–Bremerhaven–Cobh. She was sold in 1964 and since then has had a number of owners. On 18 January 1994 the ship ran aground off the west coast of Fuerteventura in the Canary Islands. The decaying wreck could still be seen on the beach of Playa de Garcey up to 2008 but the power of the Atlantic has now reclaimed her and now all that is visible of this once magnificent ship is twisted metal.

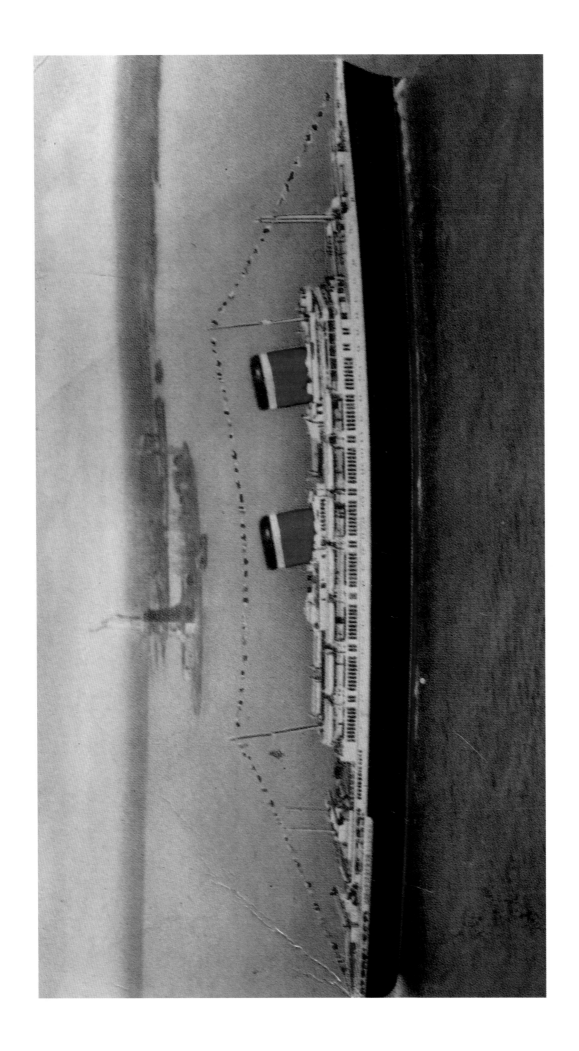

The tag from Mary Sullivan's trunk.

Hanging behind a door was a dress with its purchase labels still intact – 'You can relax … This is ARNEL'. Did items of fashion in places like Queens and Brooklyn have no place in rural Ireland of the 1950s? Did Mary ever get the chance to wear them?

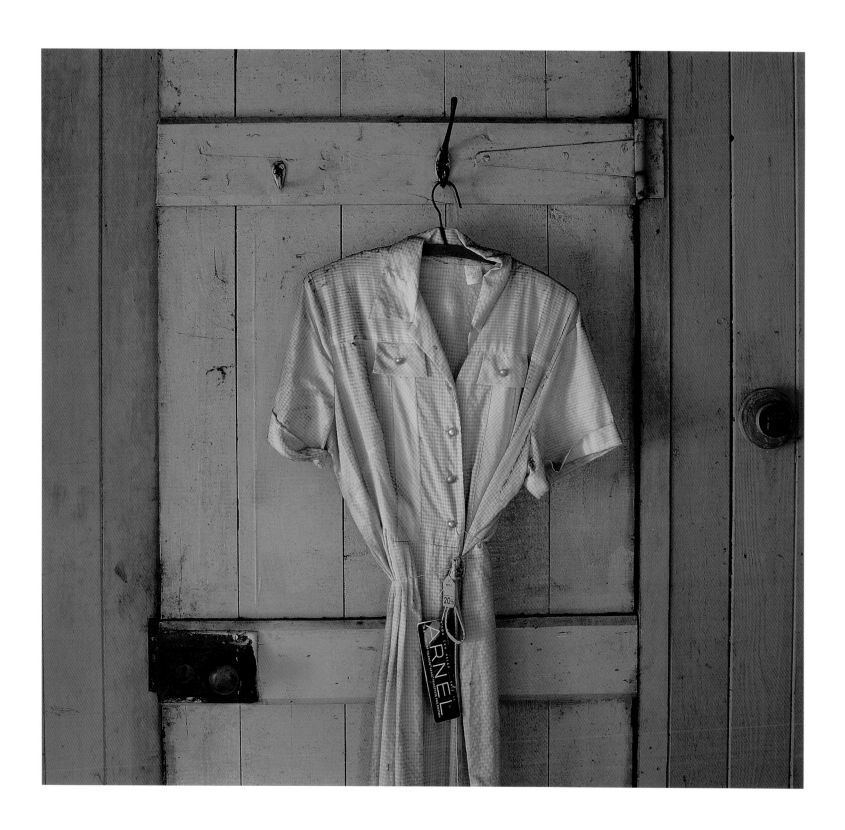

The hatbox has a label for a stateroom on a United States Lines ship while the trunk is marked with the word COBH. The dress has seen better days and has a safety pin in place of a missing button.

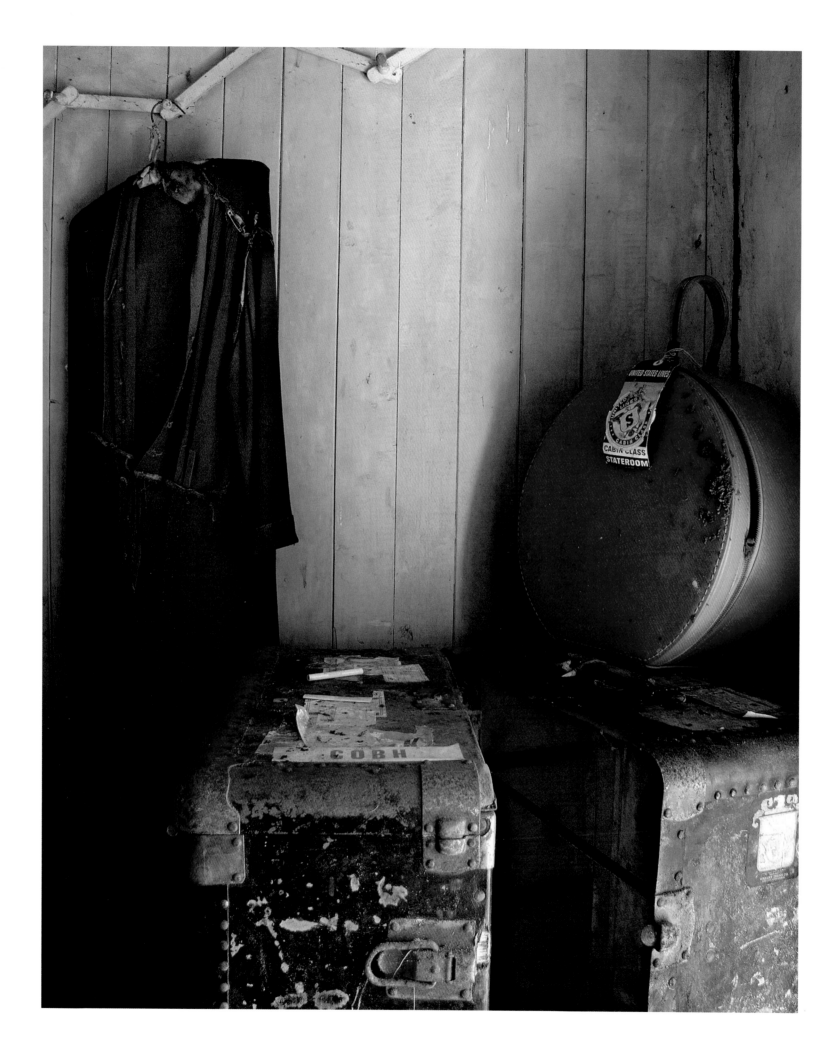

A few months before I took this photograph, a friend suggested that I stop taking 'such sad images' but I knew I would stop when I felt the project was finished.

The image contains a letter from the Railroad Retirement Board in Chicago, a jar of Morgan's hair colour restorer and a last will and testament. James Lucey Attorney of law in San Francisco made out the will on 30 September 1942. The statue reminds me of the Christ the Redeemer that overlooks Rio de Janeiro. When I returned to the house some months later I found the roof had fallen in and many of the contents had been destroyed. I knew then I had reached the end of this journey.

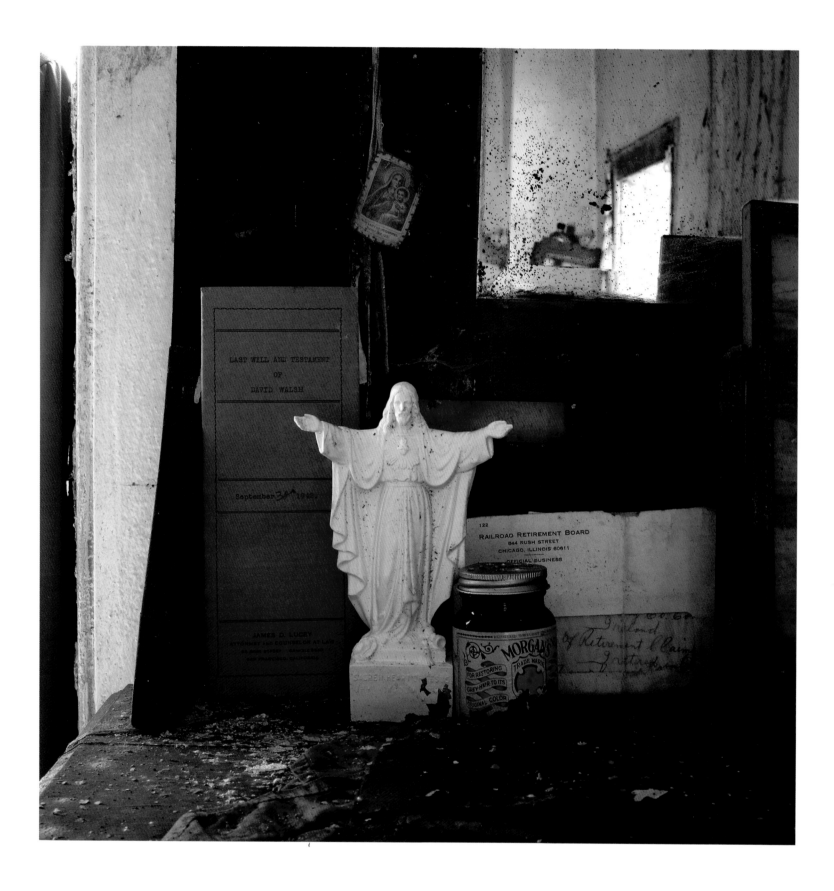

EPILOGUE

'The common talk amongst parents in the towns, as in rural Ireland, is of their children having to emigrate as soon as their education is completed in order to be sure of a reasonable livelihood.'

T. K. Whitaker, Economic Development, 1958

It is over fifty years since those words were written and yet, they seem just as relevant today. In the final decade of the twentieth century Ireland experienced unprecedented growth in its economy. Investors in foreign multi-nationals were attracted to the country by low corporate tax rates and a well-educated workforce. Prosperity and wealth followed and it seemed anyone who wanted a job got one. Ireland was no longer a country of emigration – instead, workers came to the country to help make up the required workforce. But it seemed Ireland's wealth was all built on sand. Emigration has started again as more and more young people have decided they have no future in the country.

Emigration has always been a safety valve for the Irish economy during bad times. In the 1980s we watched parents break down at airports as they said goodbye to their children who were leaving for London, Boston or Chicago. Today these images are back on our television screens: this is something we thought we would never see again.

The traditional outlet for the Irish emigrant was the UK but they face similar economic difficulties and work there is scarce. America tightened its controls with regard to illegal workers after 9/11, making it harder for people to gain entry. Today it is estimated that there are over 50,000 undocumented Irish living there, including young men and women who can never return, not for the simple things like a holiday or a family get-together or the important things like a final farewell to a parent, for fear of not being allowed back in to the country.

The homes I photographed between 2005 and 2007 are now crumbling. Modern versions can be seen in the ghost estates all over the country. The new ghost houses are as silent as the ones I photographed but at least the houses in this book were once homes.

David Creedon

ACKNOWLEDGEMENTS

I would like to thank all those who provided assistance in bringing this entire undertaking together.

Sarah McCarthy, Chicago, USA, for her vision, soul and belief in this project, and without whom it would never have happened.

Tim O'Sullivan for all his guidance, encouragement and unwavering support.

Dr Breda Gray, University of Limerick

Andrea Halpin

Nigel Hickey

Mary Johnson

Harjeet Kaur, London

Kieran Keohane PhD., National University of Ireland

Colin Leahy

Ian McDonagh, Cork County Council Arts Department

Shelley Meenehan

The British Council

Sheila Wholihane

Heather Brett for giving me kind permission to reproduce her beautiful poem 'Oh Ireland'

Linda Keohane for allowing me to use her short story 'Clooneygorman, 21 July 1969'

Representation: Helen Burke, IPN Photo Agency, Dublin
www.davidcreedon.com

First published in 2011 by
The Collins Press
West Link Park
Doughcloyne
Wilton
Cork

British Library Cataloguing in Publication data
Creedon, David.

Ghosts of the faithful departed.
1. Abandoned houses—Ireland—Pictorial works.
2. Ireland—Social conditions—20th century—Pictorial works. 3. Ireland—Emigration and immigration—Social aspects—Pictorial works.
I. Title
941.5'082'0222-dc22

ISBN-13: 9781848891258

Typesetting & Design by Anú Design, Tara
Typeset in Grotesk
Printed in Dubai by Oriental Press